IMAGES
of America

TAZEWELL
COUNTY

LOOKING FORWARD

REMEMBERING THE PAST

The Tazewell County flag was selected to represent the county by the county's governing body, the Tazewell County Board of Supervisors, in 2005. (Courtesy of the Tazewell County Board of Supervisors.)

On the Cover: The interior of the old *Clinch Valley News* building is pictured about 1923. Seated at left with an unknown visitor is J. A. Leslie, who purchased the business in 1895. The newspaper was first published in 1845 and is recognized as one of the oldest newspapers in Virginia. The building on Main Street has been renovated and is currently the office for the Tazewell District United Methodist Church. (Courtesy of the Leslie files.)

IMAGES
of America

TAZEWELL
COUNTY

Louise B. Leslie and Dr. Terry W. Mullins

ARCADIA
PUBLISHING

Published by Arcadia Publishing
Charleston SC, Chicago IL, Portsmouth NH, San Francisco CA

Printed in the United States of America

Library of Congress Catalog Card Number: 2005933462

For all general information contact Arcadia Publishing at:
Telephone 843-853-2070
Fax 843-853-0044
E-mail sales@arcadiapublishing.com
For customer service and orders:
Toll-Free 1-888-313-2665

Visit us on the Internet at www.arcadiapublishing.com

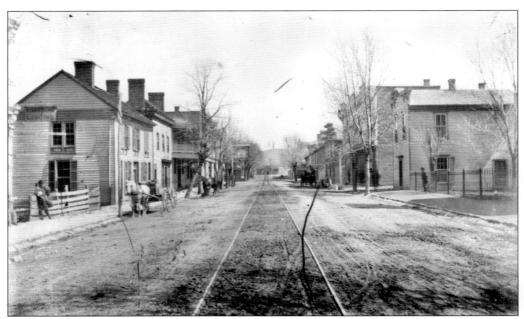

Main Street in Tazewell is seen around 1900, when trees lined one side and horses were the mode of transportation. The streetcar track is visible. On the left is the sign for the grocery business Buston and Son, which was said to be the "best grocery store west of Roanoke." (Courtesy of the Tazewell County Historical Society.)

CONTENTS

ACKNOWLEDGMENTS

Without the help and interest of our good friends throughout Tazewell County, Images of America: *Tazewell County* would not have been possible. We deeply appreciate everyone who donated pictures, furnished information, and encouraged us to complete this project. It is by no means a complete history of Tazewell County, but we hope the pictures and text will give readers a glimpse into the county, which is entering its 207th year as an integral part of the Old Dominion.

We offer special thanks to Susie Shrader and the Tazewell County Historical Society; Laurie Roberts and the Tazewell County Public Library; Mel Grubb; Hal Brainerd; Bryan Warden; Gaynelle Thompson; Bill Patton; Mark Proffitt; Clara Corell; Barbara Gillespie; Keith Hovis; Marshall Miller and Associates; Irma Webb; Stephanie Van Dyke and Charlotte Sacre of Thompson and Litton; Jane Willis and the Virginia Tech Photographic Collection; Cindy Lowe; Rick Fisher; Robert Perry; Henry Bowen Frazier III; and Walter M. Sanders III.

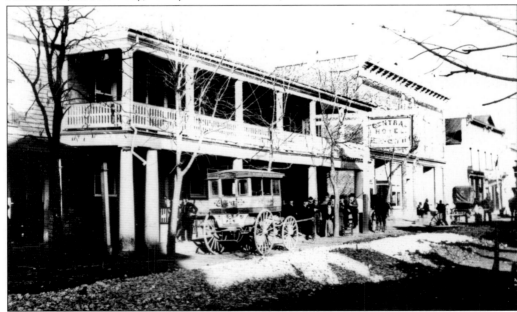

Tazewell's Main Street is pictured in the days when the town was called Jeffersonville, with a group of onlookers meeting the hack bringing passengers from the train at North Tazewell to the popular Central Hotel, owned by Surface and White. The hotel building was destroyed by fire in 1903. (Courtesy of the Tazewell County Historical Society.)

INTRODUCTION

Tazewell became a Virginia county on December 20, 1799. Its formation was adamantly opposed, however, by a Mr. Tazewell, a delegate from Norfolk who could not conceive of anything worthwhile in the vast mountain region of Southwest Virginia. When his name was substituted for the original title, which is thought by some to have been Jefferson, he voted for the idea. Mr. Tazewell never visited his namesake, but his relatives in England have recognized the name with pride and even visits through the years. The English family name is spelled Tanswell.

The first hunters in the Tazewell County area were recorded in 1766. They found abundant game, and in the following years, the rich hunting lands attracted explorers who were hunters, adventurers, and even Indian fighters at times. This county was the hunting territory for the Cherokees and Shawnees, who were often bitter enemies. Although the Colonial hunters were seldom attacked, as more and more settlers pushed into the Clinch Valley region, the Cherokees and Shawnees at times reacted violently.

The natural beauty of Tazewell County was a major reason for early settlement. The rolling hills, the gentle fields, and the pleasant climate were often mentioned in the early chronicles of those who came to homestead. In fact, George W. Bickley has written that they came "with a gun in one hand, and a Bible in the other." Beginning about 1770, several families made these gentle valleys their own. Today many descendants of those first pioneers are leaders in a vibrant 21st-century Tazewell County.

The location of Tazewell County is unique in the southwest corner of the Old Dominion, surrounded by West Virginia, Kentucky, Tennessee, and North Carolina. The storied isolation of mountaineers is no longer reality today, when one can visit any of these four adjoining states and return to Tazewell County in two or three hours' time.

The county seat is the town of Tazewell. It was first named Jeffersonville in honor of Thomas Jefferson, who received every local vote cast when he was elected president in 1800. Tazewell and its neighboring town, North Tazewell, merged in 1963. The first mayor of Tazewell was A. G. May in 1874. The first mayor of North Tazewell was T. K. Hall in 1894.

There are now five incorporated towns in the county: Tazewell, Bluefield, Pocahontas, Cedar Bluff, and Richlands. They were all transformed in terms of business, population, and wealth when the great development of the coalfields came to the region at the turn of the 20th century. The excellent early historian Bickley wrote in 1852, "Coal exists everywhere although there is so much wood around that it has not been used much for fuel. When shall we have an outlet for this coal?" Within a few years, Southwest Virginia coal became known worldwide, and the story of Tazewell County coal continues to shape her economy and people.

The people of Tazewell County are known for their hospitality, their kindness, and their respect for one another. Tazewellians are also noted for their pride in home and country and their appreciation for the beauty of the mountains and valleys that make up their home. These characteristics, coupled with the variety of cultures and nationalities, create a unique mountain mixture.

Wilbur Memorial United Methodist Church stands on the west end of Tazewell's Main Street. This active church is one of the oldest congregations in the Tazewell area. The congregation was founded by freed slaves at the end of the Civil War. (Courtesy of the Tazewell County Historical Society.)

One

TAZEWELL

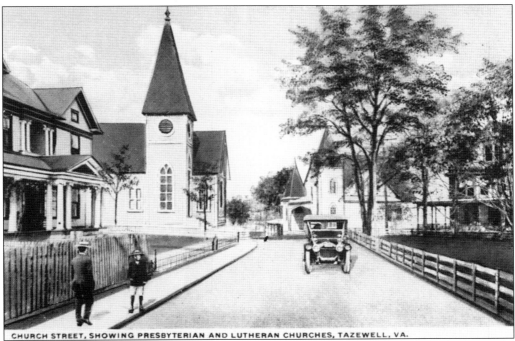

CHURCH STREET, SHOWING PRESBYTERIAN AND LUTHERAN CHURCHES, TAZEWELL, VA.

Church Street in Tazewell was named for the number of church buildings on the street and close by. This picture shows the Tazewell Presbyterian Church on the left and the Tazewell Lutheran Church on the right. The house on the right belonged to the John E. Jackson family. It was destroyed by fire. The house on the left now belongs to the Main Street Methodist Church and is the Chapman House addition. The Model T Ford is probably one of the first cars in Tazewell. (Courtesy of the Tazewell County Historical Society.)

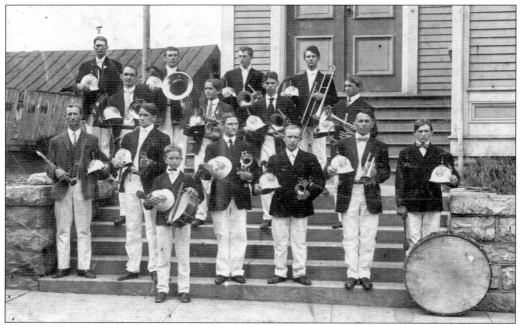

The Tazewell Marine Band, active around 1900, was a group of serious musicians who played for many community activities. They are standing in front of the first Tazewell High School building on Main Street. The steps and rock wall are currently part of the entrance to the Tazewell County Library. (Courtesy of the Leslie files.)

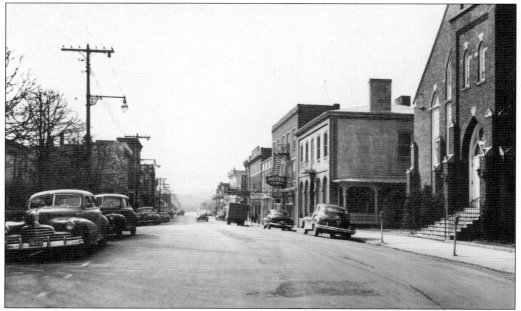

This 1949 Main Street scene shows the Main Street Methodist Church, the old Farmers Bank of Clinch Valley, Hotel Tazewell, and the remains of the streetcar tracks, which were later removed by the town crews. (Courtesy of the Norfolk and Western Historical Photograph Collection at Virginia Tech.)

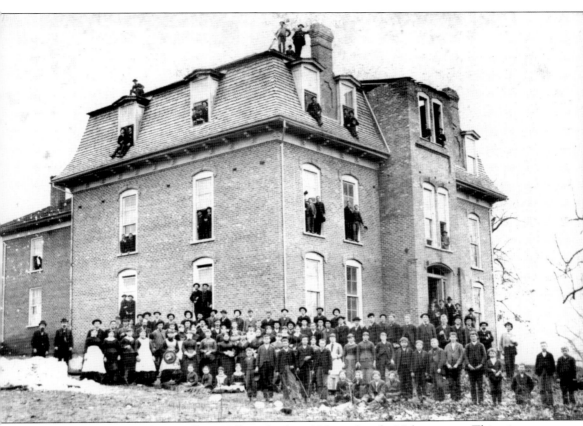

Tazewell College stood on College Hill in the late 19th and early 20th century. This picture indicates a large enrollment of boys and girls. The college had extremely high standards and emphasized the study of Latin, Greek, and mathematics. In 1894, the college head was President Ramey. This building later burned. (Courtesy of the Tazewell County Historical Society.)

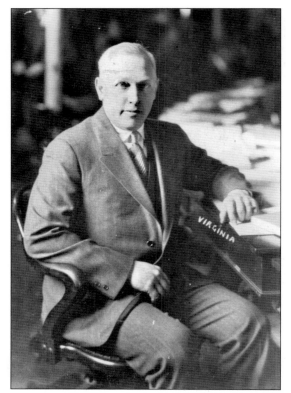

Dr. J. Walter Witten sits at his desk in the Virginia House of Delegates. He later served in the Virginia Senate. Dr Witten was an excellent doctor and the foster father to hundreds of boys who now live around the world. Dr. Witten's many contributions will long be part of the history of Tazewell County. A cabin at the Historic Crab Orchard Museum is preserved in memory of Dr. Witten and includes memorabilia telling the story of this unique man. (Courtesy of the Tazewell County Historical Society.)

George Campbell Peery and his wife, Nannie Gillespie Peery, pose for a photograph shortly after their marriage. In 1934, Peery was elected governor of Virginia, the first Tazewell native to fill the state's highest office. The eminent writer Douglas Southall Freeman wrote this description of the Peery term: "an administration of quiet vigor, of indisputable courage, of the soundest common sense and well bottomed progress." (Courtesy of the Tazewell County Historical Society.)

Dr. Mary Elizabeth Johnston-Brittain was Tazewell's first woman doctor. She joined her father, Dr. P. D. Johnston, in his Tazewell practice. In 1955, she was named General Practitioner of the Year by the Virginia Medical Society, the first woman in the state to receive this honor. She was a partner with Dr. Rufus Brittain in the Jeffersonville Hospital. Dr. Johnston-Brittain was one of the first women to serve on the Tazewell Town Council. (Courtesy of the Tazewell County Historical Society.)

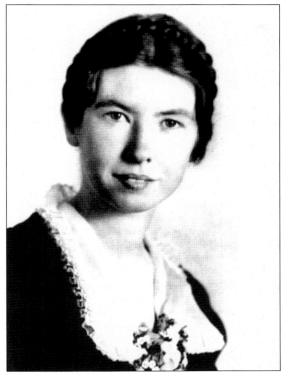

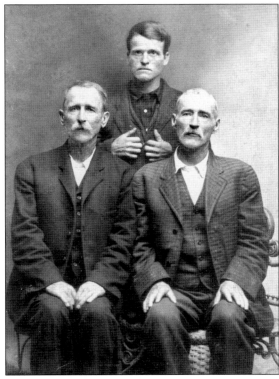

The Kincer brothers were outstanding stonemasons in early Tazewell, and their work is a unique part of Tazewell's scenery. Their work is especially appreciated in the stone wall in front of the Tazewell Library, in front of many homes on Fincastle Turnpike, and at the Tazewell Baptist Church. For a while they worked with another artist named Vermillion. It has been noted that repairs to the walls, seldom necessary, can never duplicate the fine work of the Kincers. (Courtesy of the Tazewell County Historical Society.)

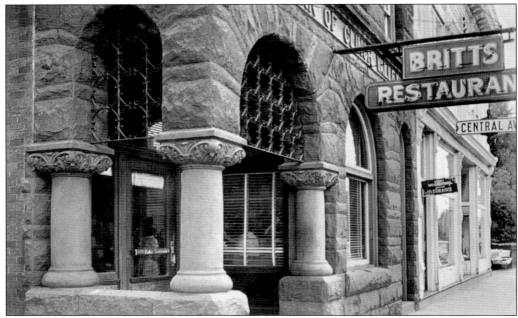

The former Britts Restaurant, established in 1932, was in this unique brownstone building on Main Street. Yong's Cuisine is currently in this building, which was first the Bank of Clinch Valley, a forerunner of the present Bank of Tazewell County. The school board office was also here at one time. This building is one of the southernmost examples of brownstone construction. The interior ceiling is also noted for its beauty. This block, which formerly included Jeff Ward's Store, is now owned by Tazewell County. (Courtesy of the Leslie files.)

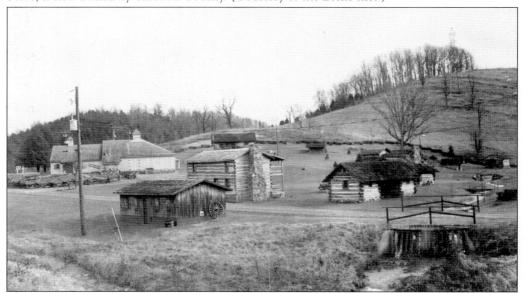

Historic Crab Orchard Museum and Pioneer Park is recognized as one of the best museum collections and displays in Southwest Virginia. It is located close to the original settlements of the pioneer families and close to the extensive Native American village uncovered by highway work. This setting adds to its charm and widespread interest. (Courtesy of Gaynelle Thompson.)

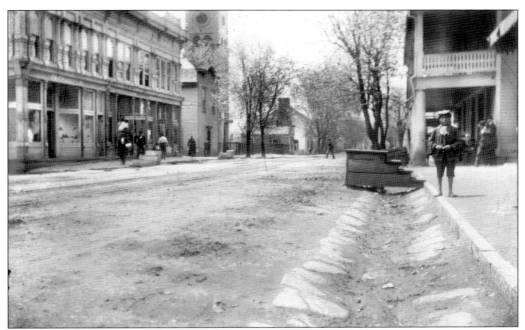

A young attendant at the Central Hotel awaits streetcar passengers on Main Street around 1902. The Tazewell County Court House tower is seen across the street. (Courtesy of the Tazewell County Historical Society.)

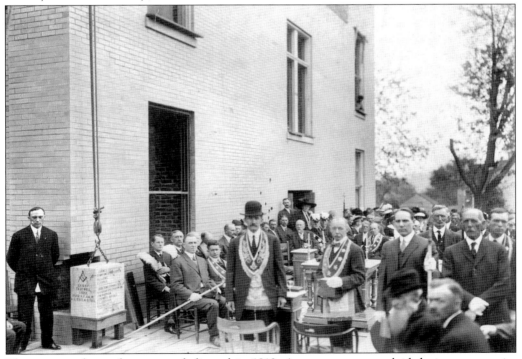

The renovated courthouse was dedicated in 1913. A cornerstone was laid during ceremonies conducted by the Masonic Lodge. (Courtesy of the Tazewell County Historical Society.)

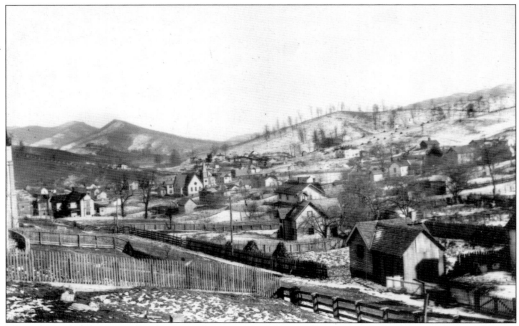

This undated photograph of a sparsely populated Tazewell apparently looks west from a hilltop above Tazewell Avenue. (Courtesy of the Leslie files.)

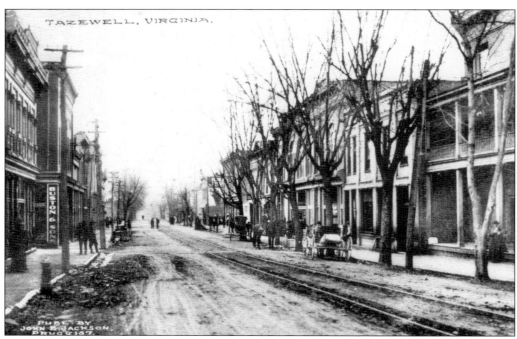

A 1920 day on Tazewell's Main Street shows one horse and wagon traveling beside the streetcar tracks. Possibly the men and women are waiting for the streetcar. At left, the office sign of Dr. Thompson, dentist, can be seen. (Courtesy of the Leslie files.)

16

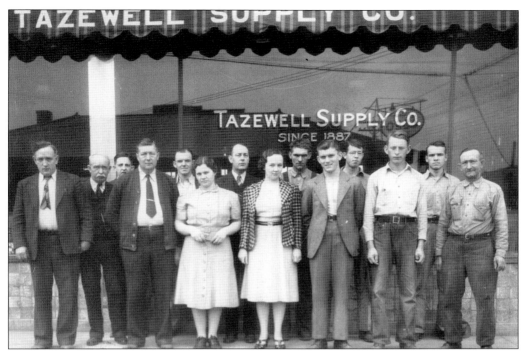

The Tazewell Supply Company was founded in North Tazewell in 1887. This employee picture, taken in April 1940, shows, from left to right, Charles F. Peery, Robert H. Ireson, J. C. Ireson, Clarence Neal, Peyton Greear, Lois Floyd, Garland Peery, Ella Greear, Jeff Asbury, Sonny Porter, two unidentified people, Jack Ireson, and Will Moore Ireson. It is said that anything could eventually be found at the Tazewell Supply if the customer was patient. (Courtesy of Ella Greear files.)

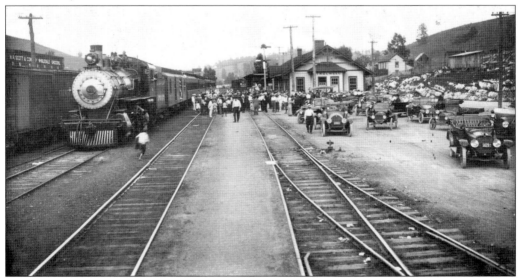

There was great excitement at the North Tazewell depot when the passenger train came in. This must have been a special day during the 1920s. (Courtesy of Norfolk and Western Historical Photograph Collection at Virginia Tech.)

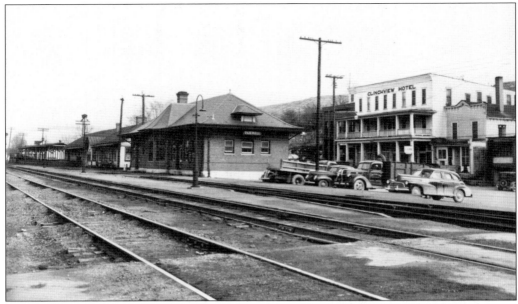

The North Tazewell depot was beside the Clinchview Hotel. When the passenger trains came into North Tazewell on a regular schedule and "drummers"—traveling salesmen—rode the trains to travel from place to place, the Clinchview Hotel was very popular. The accommodation and the fine food were known to all regular travelers. There was an upstairs porch where hotel guests gathered in the late evenings to watch the activities around the busy depot. (Courtesy of Norfolk and Western Historical Photograph Collection at Virginia Tech.)

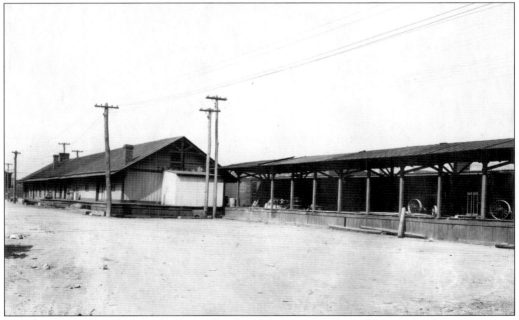

The freight yards at the North Tazewell railroad depot were always busy in the days when most handling of freight and livestock from the area was done by rail. (Courtesy of Norfolk and Western Historical Photograph Collection at Virginia Tech.)

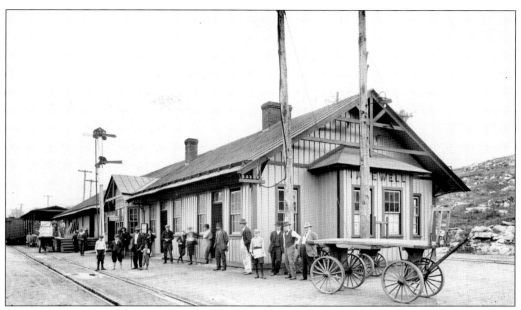

Railroad enthusiasts of today can understand the excitement these men and boys seem to feel as they wait for the whistle to sound around the bend. In the early days, the train meant excitement and gave many a young person a feeling of wanderlust. (Courtesy of Norfolk and Western Historical Photograph Collection at Virginia Tech.)

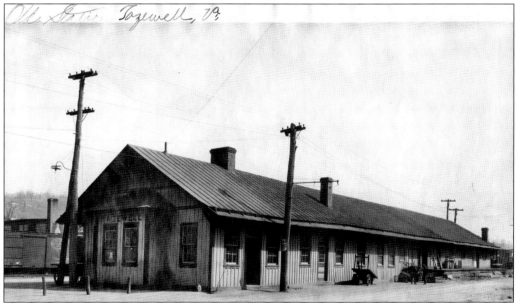

Three Norfolk and Western station agents at the North Tazewell depot who are well remembered are the late Mr. and Mrs. L. L. Dickenson and the late Major Hatfield. When the passenger service was discontinued, much of the business at the local level was gone. Coal trains still travel along the North Tazewell tracks on their route from the coalfields to the ports on the East Coast and top Northern cities. (Courtesy of Norfolk and Western Historical Photograph Collection at Virginia Tech.)

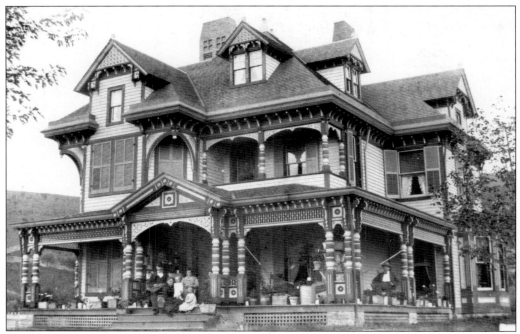

The George P. Hall house on Riverside Drive in North Tazewell was built in 1896, and this picture was taken around 1900. The Hall family and guests are on the porch. On the side porch to the right is T. K. Hall, the first mayor of North Tazewell. The ornate designs are typical of the era. This house was always pointed out to railroad passengers as they went in and out of the North Tazewell depot. (Courtesy of the Tazewell County Historical Society.)

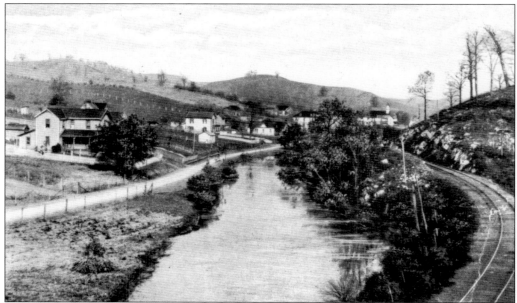

This tranquil scene along the Clinch River beside the railroad tracks has not changed much in the past century, except that more houses fill the hillsides. (Courtesy of the Tazewell County Historical Society.)

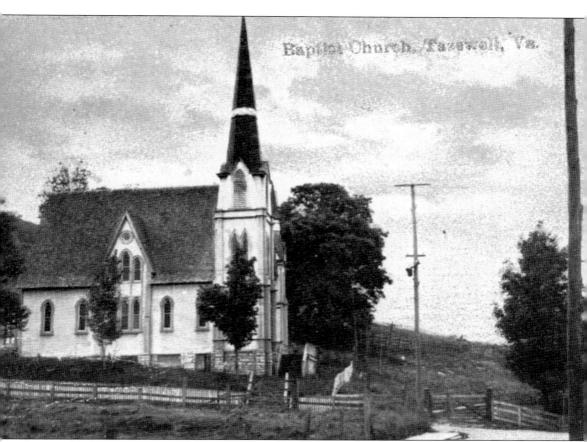

Baptist Church, Tazewell, Va.

Thomas M. Hawkins, a master builder in early Tazewell, built the Tazewell Baptist Church in 1890. In the first years, it stood alone on a small hillside, but now houses fill the streets close by. (Courtesy of the Leslie files.)

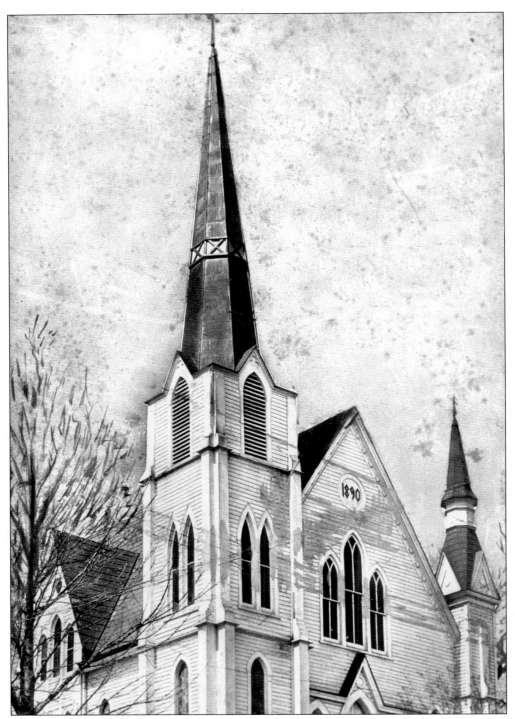

The bell at the Tazewell Baptist Church was donated by financier John D. Rockefeller after he was asked to help with its purchase. Its mellow tone is part of the sound of Tazewell's Sunday mornings. (Courtesy of the Leslie files.)

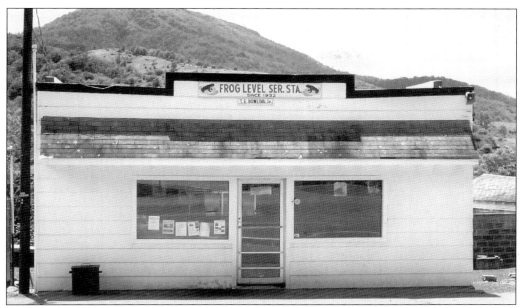

The Frog Level Service Station is a unique tourist attraction close to the town of Tazewell. For many years, it has had the extra distinction of being called the Frog Level Yacht Club. Plum Creek is close by, but the "yachts" are in the imagination of those who visit owner and native June Bowling and the regulars who spend many leisure hours at the establishment. (Courtesy of Terry W. Mullins.)

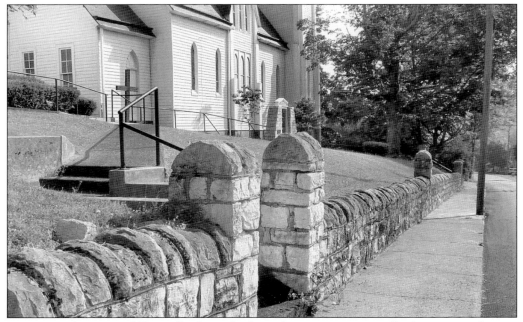

Visitors to the town of Tazewell often ask about the unique stone walls that surround many parts of the town. A good example is the stonework in front of the Tazewell Baptist Church. The Kincer brothers did the beautiful work in the 19th century. It has been said that their artistry cannot be duplicated. (Courtesy of Terry W. Mullins.)

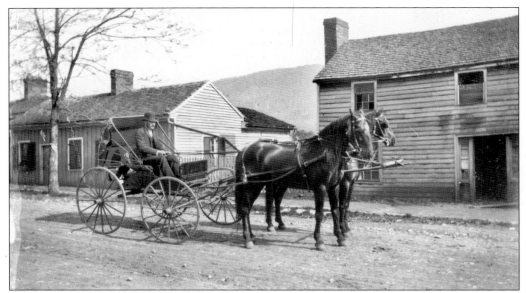

The west end of Tazewell's Main Street is pictured here about 1900. Most of the houses in this area have been torn down to make room for businesses and for more modern means of transportation. (Courtesy of the Tazewell County Historical Society.)

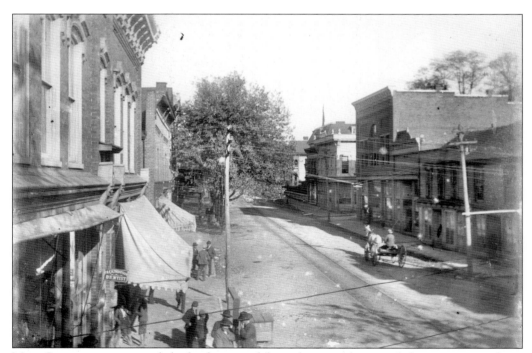

Main Street was quiet until the hacks arrived from the train depot and the streetcar made its rounds to bring visitors and drummers to the hotel in the early 20th century. (Courtesy of the Tazewell County Historical Society.)

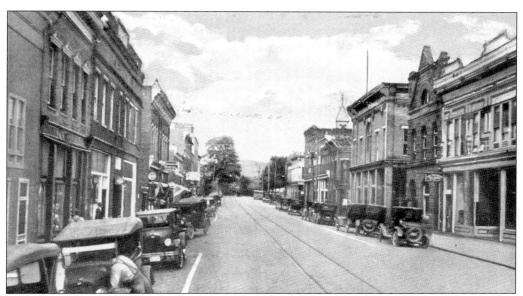

Looking east up Main Street, one follows the straight tracks of Tazewell's streetcar. The car ended its meanderings in 1932, but during its 30-year history, it was the chief means of transportation between Tazewell and North Tazewell. Advertisements were placed on the sides of the streetcar, and at times it was reserved for parties. The Dick Kelly family had a dog that rode the streetcar each day from Tazewell Avenue to Main Street. (Courtesy of the Leslie files.)

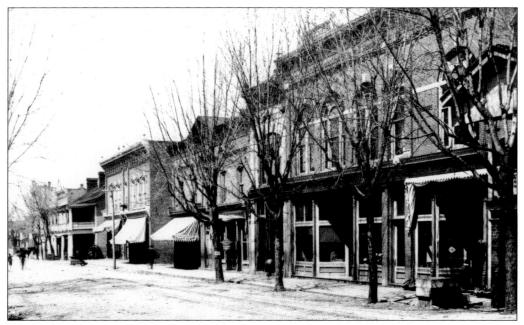

When the trees were cut about 1930, there was opposition from those who appreciated their beauty and shade on summer days, but automobiles took the place of horses, and more room was needed to take care of growing traffic as Tazewell developed in the 1930s and 1940s. This early picture is a tranquil scene when times were slow. (Courtesy of the Leslie files.)

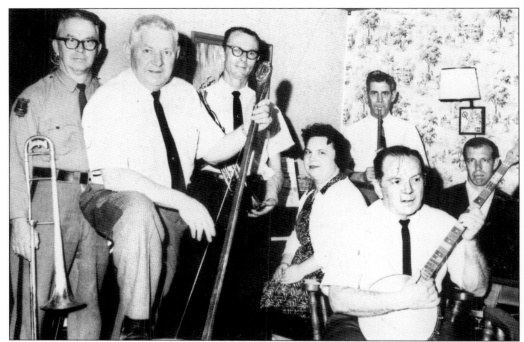

In the 1950s and 1960s, the Tazewell Lions Club entertained the area annually with a minstrel and variety show. Included in the local talent was this jug band, which became quite popular. Entertainers included, from left to right, Forrest Wood, Bill Hughes, Ed Thornbury, Pete Hawkins, Carl Gillespie Jr., Louise Leslie, and Jim Hughes. (Courtesy of the Leslie files.)

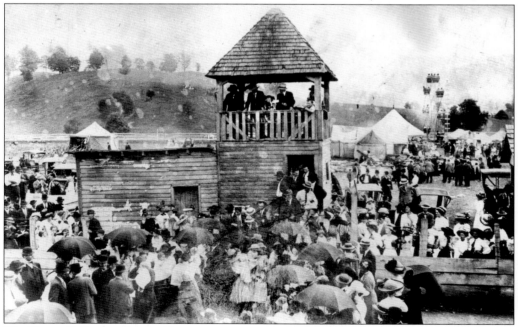

The Tazewell County Fair had become an annual event by 1900. The summer festival attracted hundreds of fairgoers every year. (Courtesy of Cindy Lowe.)

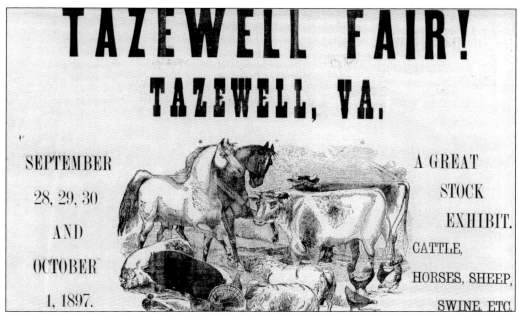

This 1897 advertisement of the Tazewell County Fair appeared after the annual event was inaugurated in 1888. Today the initial agricultural exhibits remain a highlight of the event, but the fair has grown into a multi-faceted entertainment of farm and home exhibits and shows that attract thousands each year. (Courtesy of the Leslie files.)

The headquarters for the Tazewell County Historical Society, founded in 1987, are in the former home of Annella Greever, Tazewell teacher and community leader. It is one of the oldest homes close to Tazewell's Main Street and remains a favorite landmark. Dr. C. W. Greever had his office at his home and in the adjoining building for many years. (Courtesy of Terry W. Mullins.)

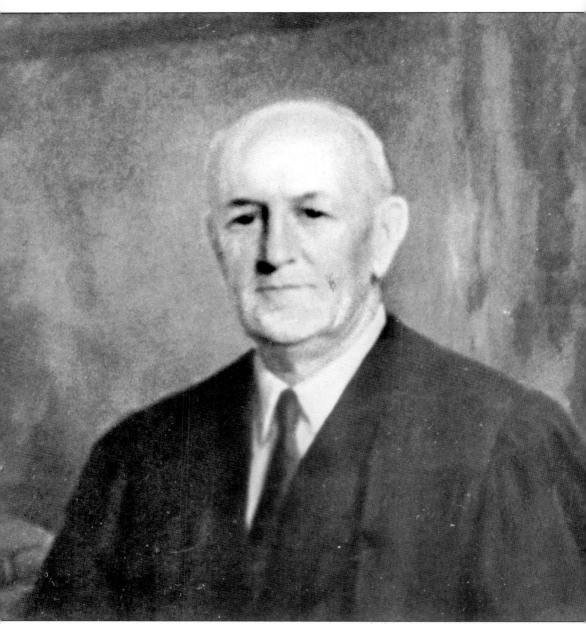

Justice Archibald C. Buchanan served on the Supreme Court of Appeals of Virginia from 1946 to 1969. He was highly respected by his colleagues and the general public, both during his service on the state bench and when he served as circuit court judge in Tazewell. (Courtesy of the Leslie files.)

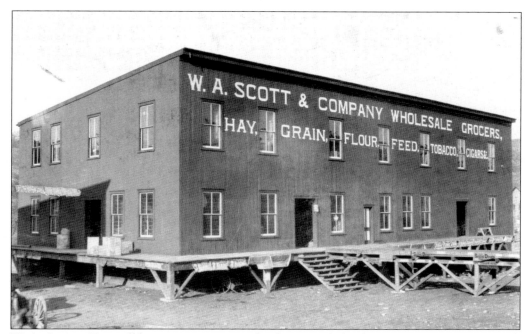

W. A. Scott, a Tazewell businessman, operated a thriving wholesale grocery operation in North Tazewell. He was known for his groceries and farm products and for the very unique Wascott ginger ale he sold, using his initials for the name. The taste of this drink is still remembered. (Courtesy of the Tazewell County Historical Society.)

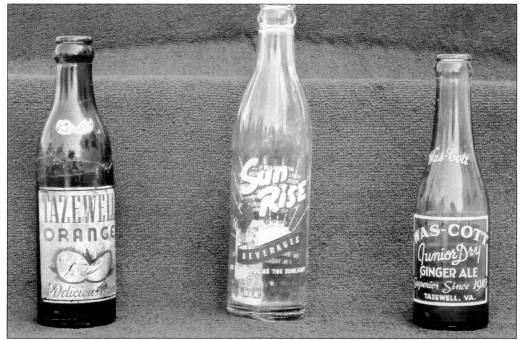

Only a few bottles with the Wascott name can be found today. His building burned in 1920 and was later rebuilt as a warehouse. (Courtesy of Terry W. Mullins.)

The first Tazewell County Jail, built in the early 19th century, was located behind the original courthouse. Its walls are said to be four bricks thick. The building continues to be used by various government organizations today. (Courtesy of Terry W. Mullins.)

Hotel Tazewell is pictured here, with a fire escape on the front of the Main Street building. This hotel stood where the present Bank of Tazewell County is located. Among the last owners were Mr. and Mrs. Kermit Monk. Adjoining this structure was the popular Pool Hall. (Courtesy of the Leslie files.)

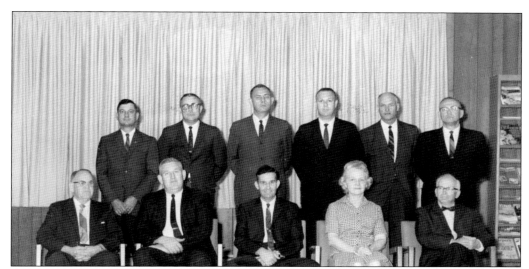

Tazewell County school principals and staff in the mid-1970s included, from left to right, (first row) Clark Brown, principal, Cedar Bluff; Dwight Speeks, principal, Graham High; Lester Jones, superintendent; Virginia Garwood, director of instruction; and Eugene Ross, principal, Tazewell High; (second row) Ed Grimm, principal, Richlands Junior High; Tom Hagy, principal, Richlands High; Ellis Fields, principal, Tazewell High; Edward Fortune, staff member; Wiley Yates, principal, Tazewell Junior High; and Monte Bush, principal, Graham Middle. (Courtesy of Lester Jones.)

Wiley R. Yates served as principal of the Tazewell Middle School when the building was dedicated in 1980. He filled this position until his retirement. (Photograph by John Fisher.)

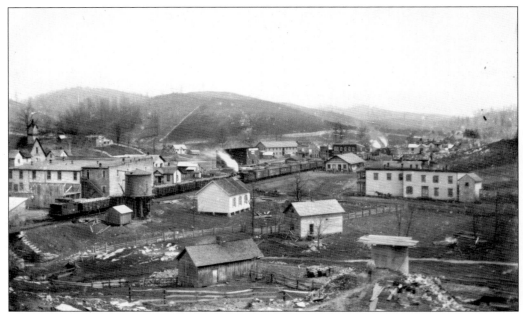

North Tazewell looks a little empty as the train wends through the valley. The community was first called Kelly and at one time was the hub for many of Tazewell County's business enterprises. On the far left is the Lutheran church, which was later sold to the Methodist congregation. (Courtesy of the Leslie files.)

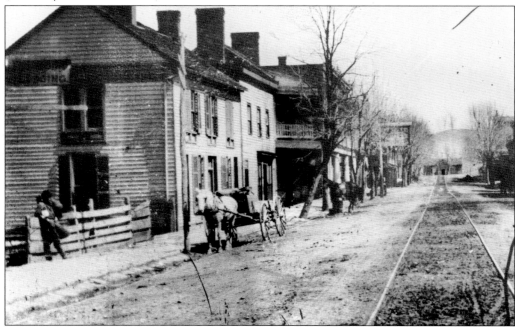

The streetcar and horses were the modes of transportation on Tazewell's Main Street around 1910. The buildings at the west end have been replaced with business enterprises in most instances, but the Greever House at the end of the street remains much the same today, and it is now the headquarters for the Tazewell County Historical Society. (Courtesy of Cindy Lowe.)

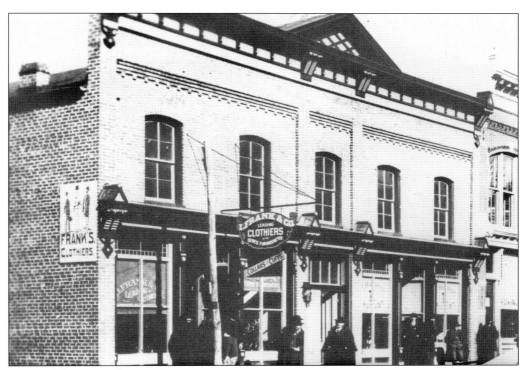

Many of the Tazewell Main Street buildings had ornate exteriors, and these still exist on some of the older buildings in use today. This is a good example of that style in the early 20th century. (Courtesy of Cindy Lowe.)

It might be court day in Tazewell, when the men rode to town to get all the news. This must be a summer day after 1892, since the streetcar tracks are in place. The first streetcars were pulled by horses. In 1902, the first electric streetcar was operated by C. C. Long. The Spotts brothers installed the first electric light system in Tazewell in 1899. (Courtesy of Cindy Lowe.)

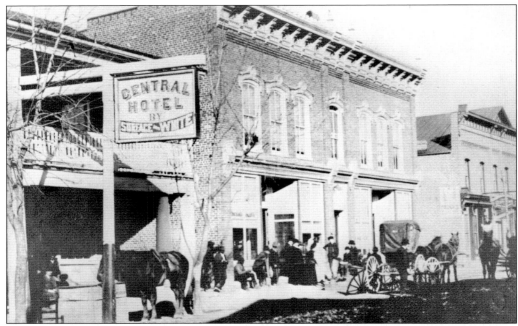

These well-dressed businessmen are waiting for the horses and buggies to bring customers to their stores or to bring drummers to sell them goods. Note the architecture of this early Main Street building. (Courtesy of Cindy Lowe.)

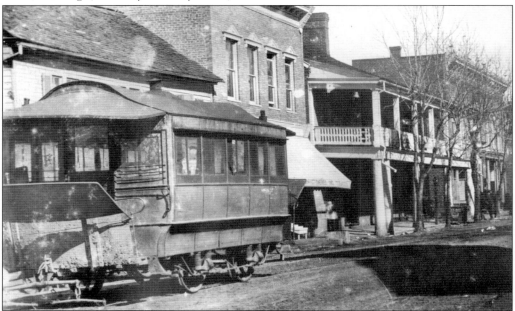

This may be the first streetcar soon after its initial runs from Tazewell to North Tazewell in 1892. Horses pulled the streetcars for the first 10 years of operation. It is said the horses were released at the top of "Horse Shoe Bend" (Fincastle Turnpike) and the streetcar ran free down to Tazewell Avenue, where the horses were waiting after a leisurely stroll down Pine Street. The building with the balcony is the Central Hotel. (Courtesy of Cindy Lowe.)

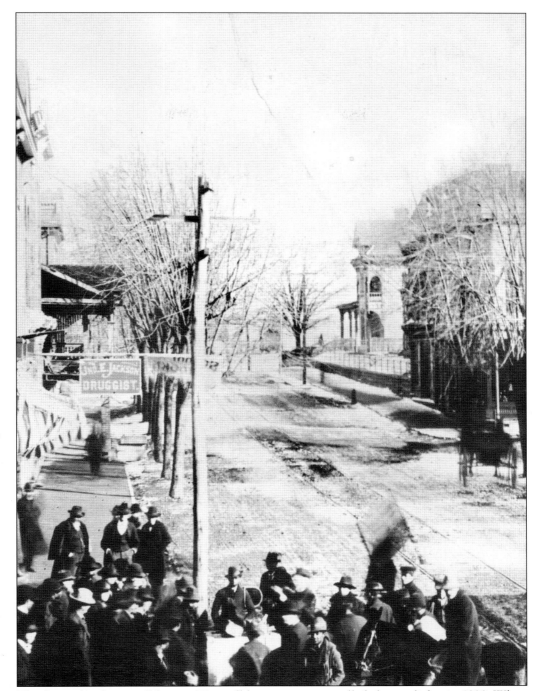

The Spotts brothers, well-known Tazewell businessmen, installed electric lights in 1899. When the streetcar was electrified in 1904, Tazewell was advertised as the "smallest town in the United States with an electric streetcar." Electric power poles seem to dominate the Main Street scene, and they were one thing (along with the coming of the automobile) that forced the cutting of the trees lining both sides of the business district. (Courtesy of Cindy Lowe.)

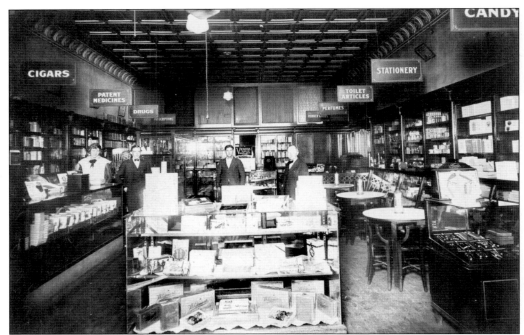

John E. Jackson founded Jackson Drug Company on Tazewell's Main Street when he came to Tazewell in 1897. He is pictured on the far right, and his son, Edward Lewis Jackson, is on the far left. The popular drug store remained in the Jackson family until 1951, when it was purchased by Harry Fugate. (Courtesy of Cindy Lowe.)

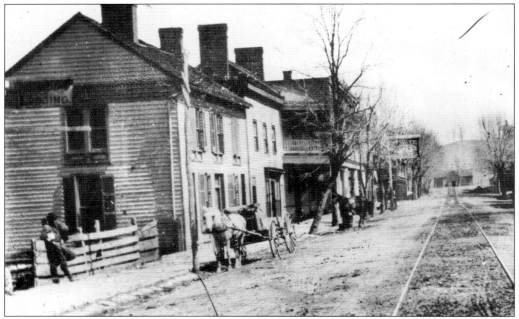

Tazewell's Main Street is seen in the early 20th century with a horse-drawn buggy, the new streetcar tracks, and the trees that were later removed when more space was required on the busy street. (Courtesy of Cindy Lowe.)

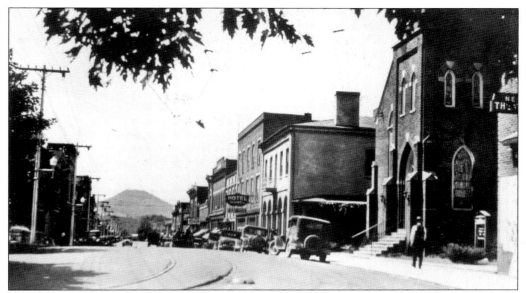

Henry Ford's first cars lined Main Street in the early part of the 20th century. In this picture, looking east, the streetcar tracks are visible. This incarnation of the streetcar ran from 1903 until 1932; it was a popular mode of transportation between Tazewell and North Tazewell, especially when passenger trains came into the North Tazewell depot. (Courtesy of the Tazewell County Historical Society.)

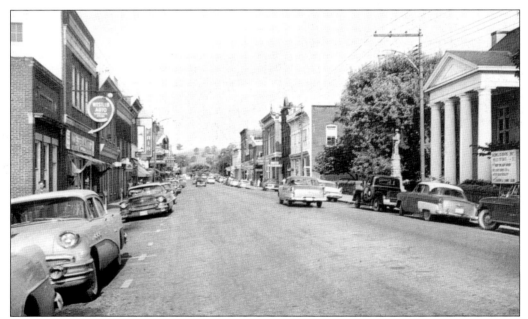

Main Street in Tazewell was busy in 1950, when Tazewell County celebrated its sesquicentennial. The county seat, originally called Jeffersonville, was incorporated in 1866. Tazewell is the oldest town in the county. (Courtesy of the Leslie files.)

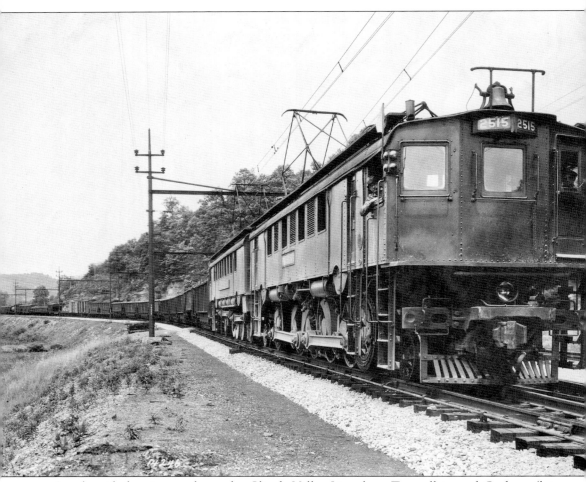

An electrified train travels up the Clinch Valley Line from Tazewell toward Graham (later Bluefield), Virginia, in 1910. (Courtesy of the Norfolk and Western Historical Photograph Collection at Virginia Tech.)

Two

BLUEFIELD

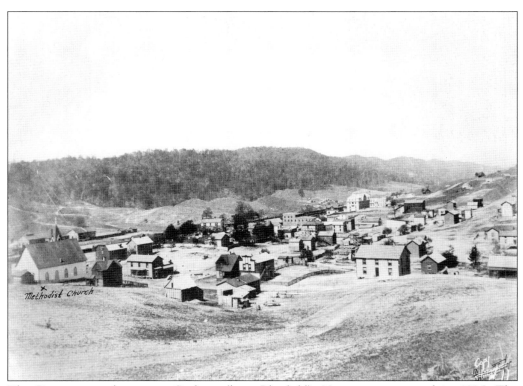

The Bottoms, or downtown Graham (later Bluefield), Virginia, is pictured in 1886. The Methodist church is on the left. (Courtesy of the Norfolk and Western Historical Photograph Collection at Virginia Tech.)

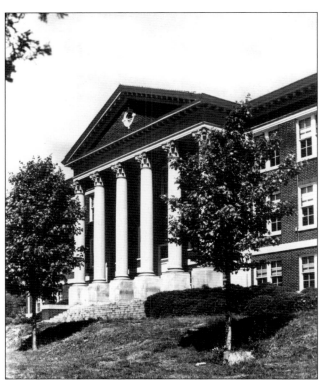

Bluefield College is pictured here in 1949. The four-year liberal-arts college was founded by the Southern Baptists in Bluefield near the West Virginia state line in 1923. (Courtesy of the Norfolk and Western Historical Photograph Collection at Virginia Tech.)

Graham Train Station is shown during the era of electrified coal trains on the Norfolk & Western. Graham later became Bluefield, Virginia. (Courtesy of the Norfolk and Western Historical Photograph Collection at Virginia Tech.)

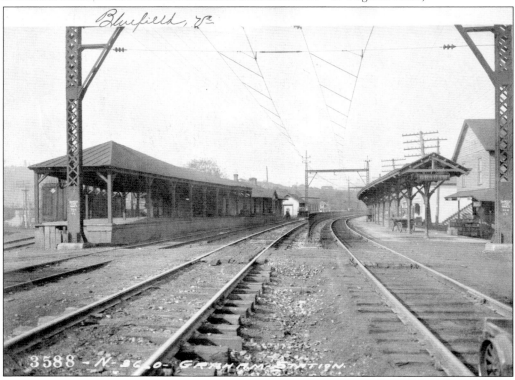

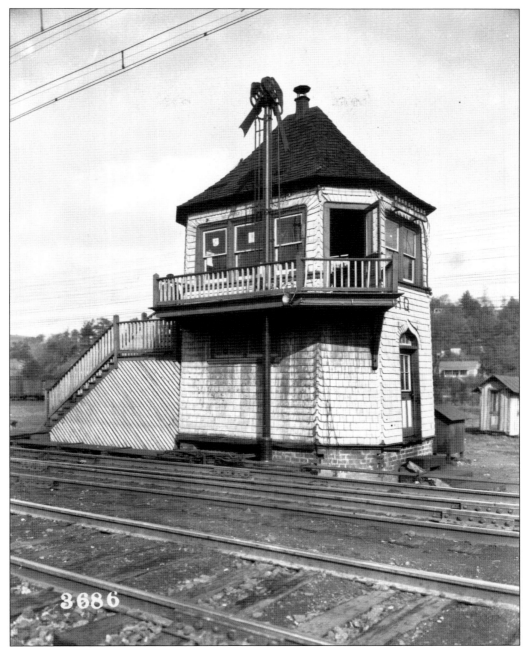

3686

This railroad signal tower was in use at the Graham Station during the early 20th century. Graham was named after one of the early leaders of the Norfolk & Western Railway, Thomas Graham. (Courtesy of the Norfolk and Western Historical Photograph Collection at Virginia Tech.)

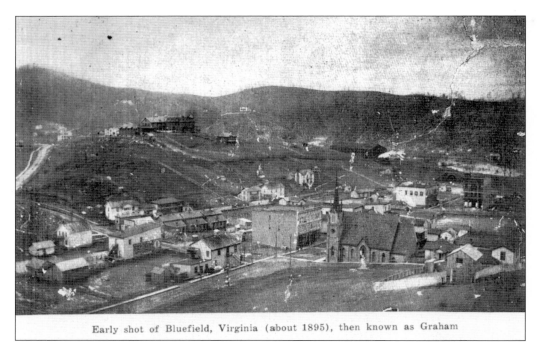

Early shot of Bluefield, Virginia (about 1895), then known as Graham

Graham is pictured here in 1895. The Graham Hotel is pictured on a hill to the right. The original Methodist church is lower right. Logan Street climbs the hill to the left. (Courtesy of Walter M. Sanders III.)

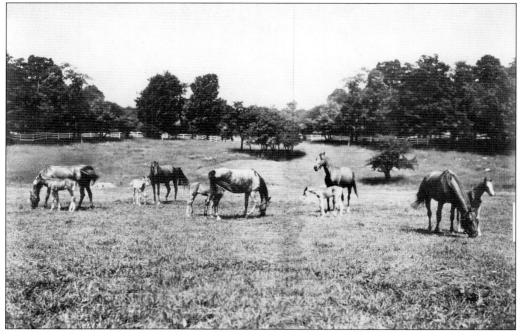

Mares and colts are grazing on the Leatherwood Farm near the West Virginia state line in Bluefield, Virginia, in this 1948 photograph. Graham changed its name to Bluefield in 1923. (Courtesy of the Norfolk and Western Historical Photograph Collection at Virginia Tech.)

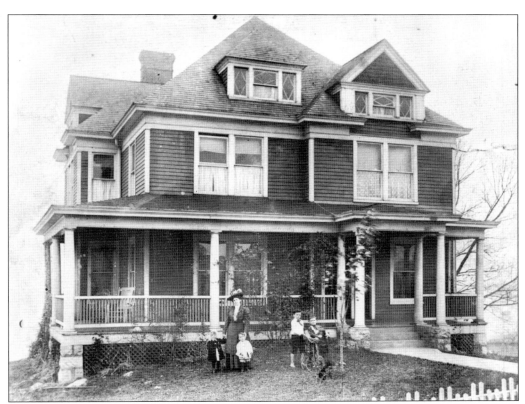

Built in 1905 at 115 Logan Street, this was the home Dr. and Mrs. Henry Bowen Frazier and family. Pictured in this 1908 photograph are Mrs. Florence McCall Frazier (1878–1946) and the Frazier children. The children are, from left to right, twins Virginia and Lucian (born 1905), McCall (born 1900), and Henry (born 1902). Dr. H. B. Frazier (1872–1940) practiced medicine in Graham from 1898 until his death in 1940. (Courtesy of H. B. Frazier III and the Ed Blair family.)

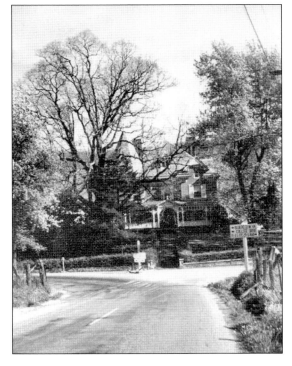

This view of the Sanders House looks up the road in 1948. To the right is the Fincastle Pike, now called Valleydale. It was then a dirt road. This road has been upgraded and elevated twice through the years. The present-day intersection is nearly 20 feet higher and looks down to the Sanders House. (Courtesy of Walter M. Sanders III.)

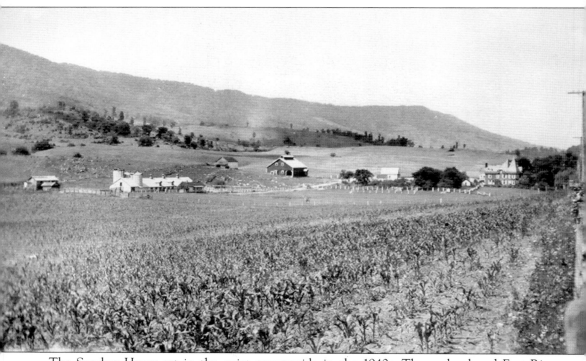

The Sanders House sat in the quiet countryside in the 1940s. The undeveloped East River Mountain is in the background. Today the house and one-and-a-half acres of yard remain unchanged. Both are now surrounded by the new Wal-Mart and its outlying shops and businesses. Much more growth is planned for the nearby open areas. (Courtesy of Walter M. Sanders III.)

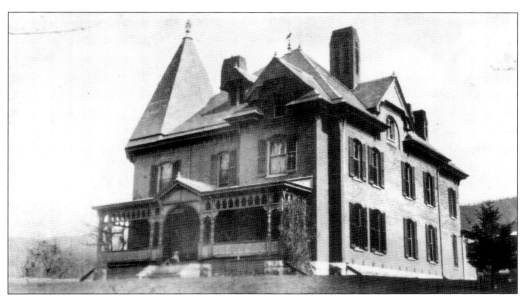

The Sanders House is the subject of this 1930s photograph meant for a postcard. (Courtesy of Walter M. Sanders III.)

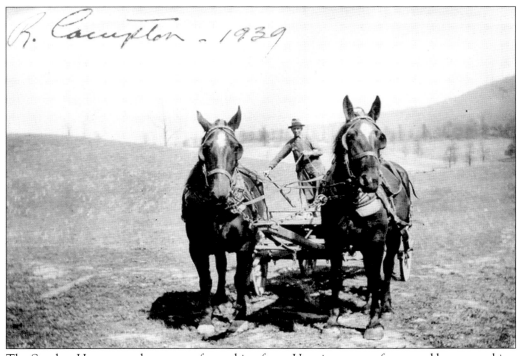

The Sanders House was the center of a working farm. Here is a scene of men and horses working on the Sanders farm. (Courtesy of Walter M. Sanders III.)

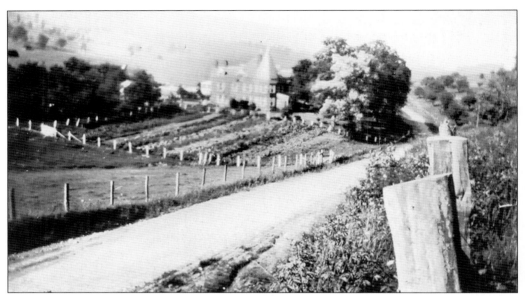

A large garden and apple orchard at the Sanders House and Farm are shown here looking from the east. (Courtesy of Walter M. Sanders III.)

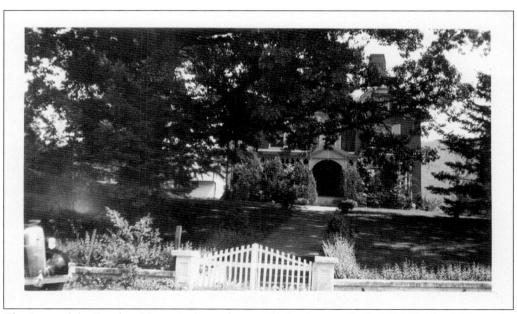

The front of the Sanders House is shown here with the front end of a 1936 Buick visible to the left. (Courtesy of Walter M. Sanders III.)

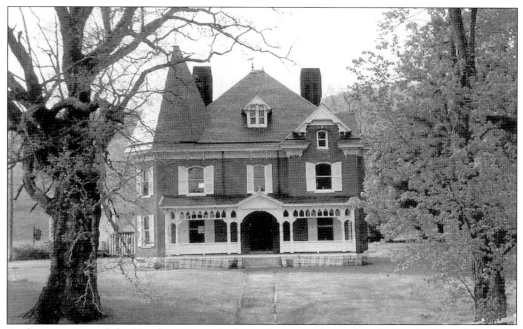

A close-up view of the Sanders House is shown here not long after the beginning of the 20th century. This photograph is dated 1906. (Courtesy of Walter M. Sanders III.)

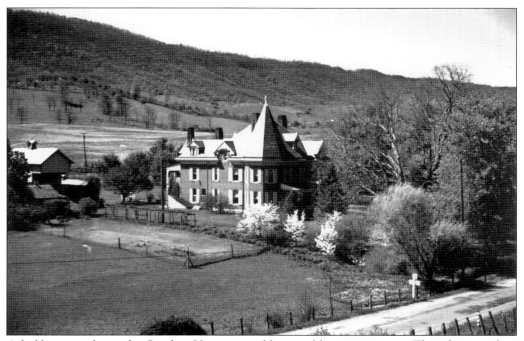

A half century later, the Sanders House resembles an old country estate. This photograph is dated 1956. (Courtesy of Walter M. Sanders III.)

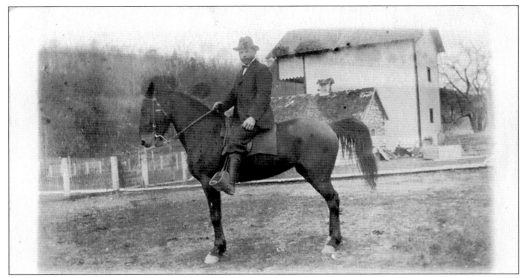

Mr. Lefler, the Sanders farm foreman, is shown here riding Nellie. The photograph was taken in the back lot about 1910. (Courtesy of Walter M. Sanders III.)

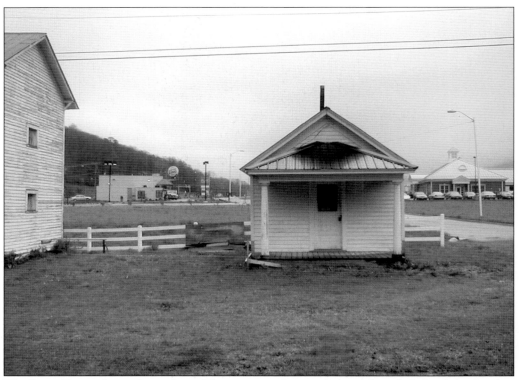

The Rosie Trigg cabin is shown here. The servant cabin was located directly behind the Sanders House. The structure serves as a visitor's center today. (Courtesy of Walter M. Sanders III.)

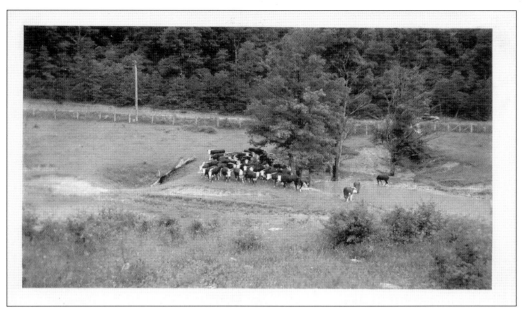

This herd of Texas cattle roamed on the working Sanders farm. (Courtesy of Walter M. Sanders III.)

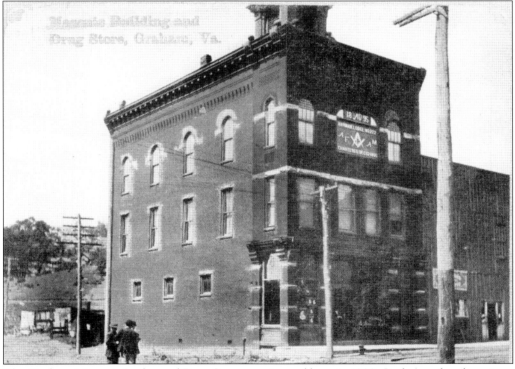

The Graham Masonic Lodge and Drug Store are pictured here in 1909. Graham, a bustling sister town of Bluefield, West Virginia, changed its name to match its sister city in 1923. (Courtesy of Walter M. Sanders III.)

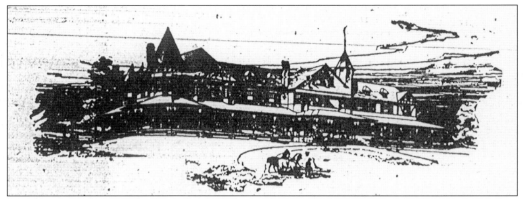

The Hotel Graham sat high on the hill above the town of Graham in the late 19th century. The hotel was totally destroyed by fire on March 3, 1898. (Courtesy of Walter M. Sanders III.)

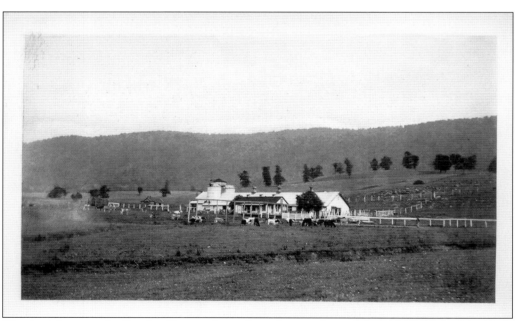

The dairy barn on the Sanders Farm is shown here. Livestock graze the field in front of the barn, and the East River Mountain provides the backdrop. (Courtesy of Walter M. Sanders III.)

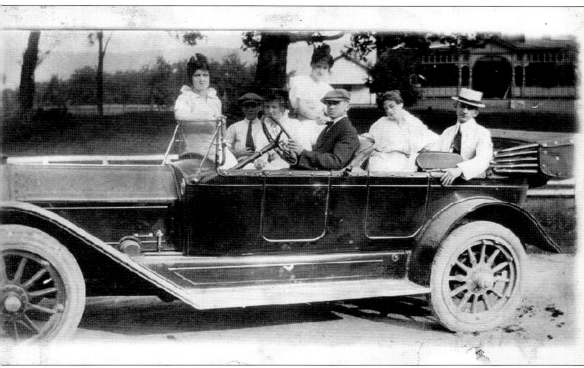

The Sanders family poses in their 1912 touring car here. Their home place, the Sanders House, is pictured in the background. (Courtesy of Walter M. Sanders III.)

Walter M. Sanders Jr. is pictured here. The Walter M. Sanders Jr. Photograph Collection is in the possession of the Sanders House and the Tazewell County Historical Society. (Courtesy of Walter M. Sanders III.)

Three

CEDAR BLUFF

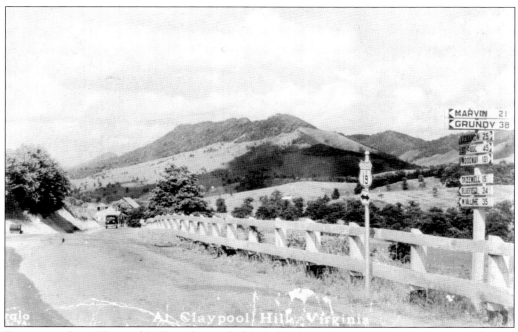

Facing east from Claypool Hill on the newly labeled U.S. Highway 19, the mileage sign indicates Tazewell is 15 miles northeast, Grundy is 38 miles northwest, and Lebanon is 25 miles southwest of the junction. Notice the car heading up the hill and the home of Harvey George Gillespie in the distance. (Courtesy of Gaynelle Thompson.)

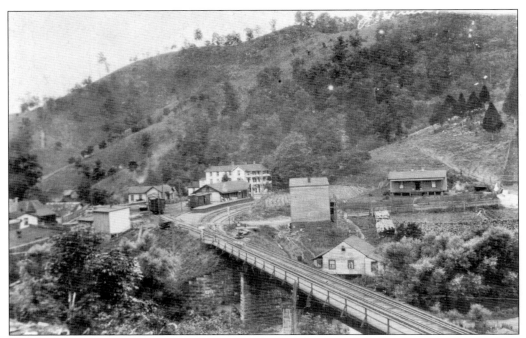

Cedar Bluff was a thriving community a decade after the arrival of the Clinch Valley Railway extension. The train station and hotel are visible in the center of the picture. (Courtesy of Gaynelle Thompson.)

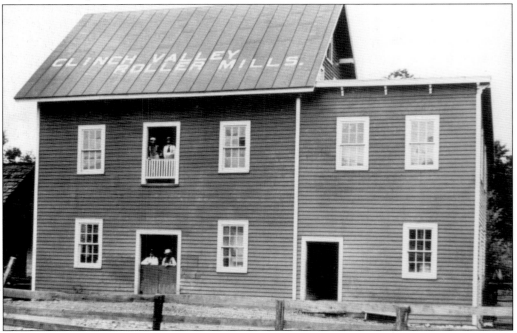

The historic Higginbotham Mill, also known as the Clinch Valley Roller Mills, has been an important business and landmark since 1893, when this picture was taken. (Courtesy of Gaynelle Thompson.)

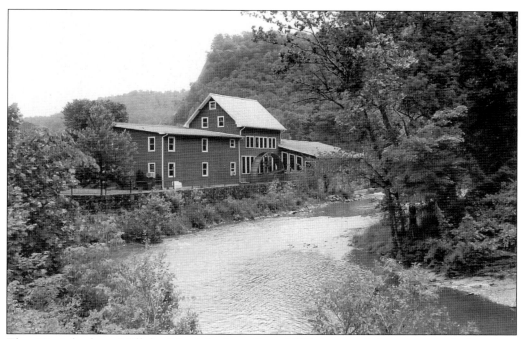

The Higginbotham Mill (or Higginbotham-Bane Mill) is one of the most scenic locations in Tazewell County. The mill remained in operation until the 1970s. (Courtesy of Terry W. Mullins.)

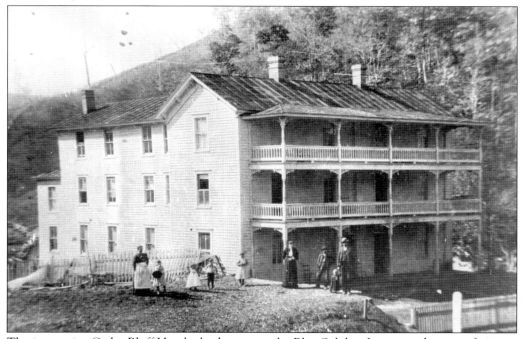

The impressive Cedar Bluff Hotel, also known as the Blue Sulphur Inn, served scores of visitors in Cedar Bluff in the early 20th century. The hotel faced the recently constructed Clinch Valley Railway Line. (Courtesy of the Tazewell County Historical Society.)

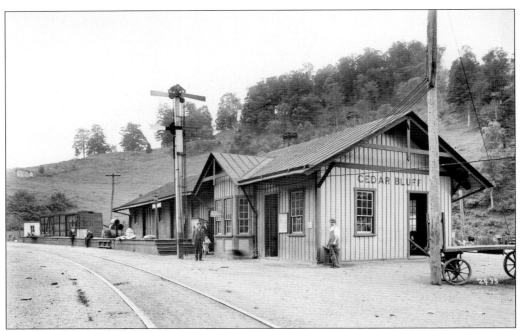

The Cedar Bluff train station served the community for many years following its construction in 1890. (Courtesy of the Norfolk and Western Historical Photograph Collection at Virginia Tech.)

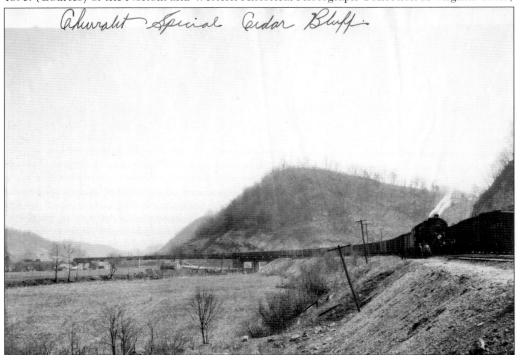

A Norfolk & Western coal train nears Cedar Bluff in the early 1920s. This train is on the Cedar Bluff–Iaeger line, which was built in 1901. (Courtesy of the Norfolk and Western Historical Photograph Collection at Virginia Tech.)

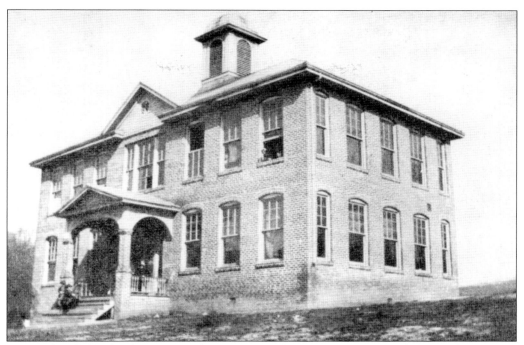

The Cedar Bluff School, constructed in 1906, served a growing number of children who formerly attended an older, overcrowded school building. This four-room brick structure was built on College Hill to serve as the high school. (Courtesy of Gaynelle Thompson.)

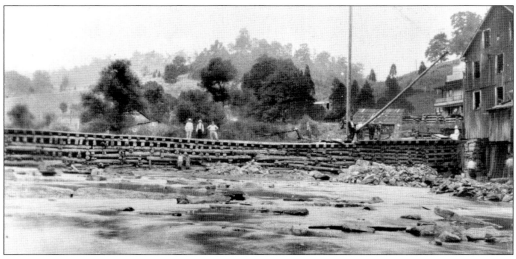

The McGuire Dam was built on the Clinch River at the mill in Cedar Bluff in the 1890s. The dam provided the water power to run the mill's giant wheel. (Courtesy of Gaynelle Thompson.)

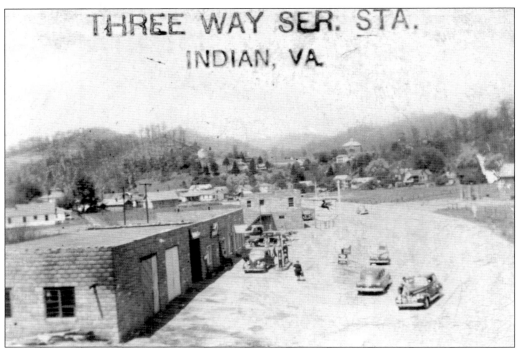

The Three Way Service Station on Main Street in Cedar Bluff is pictured around 1930. Cedar Bluff was once called Indian, since the Indian Creek empties into the Clinch River at this point. (Courtesy of Gaynelle Thompson.)

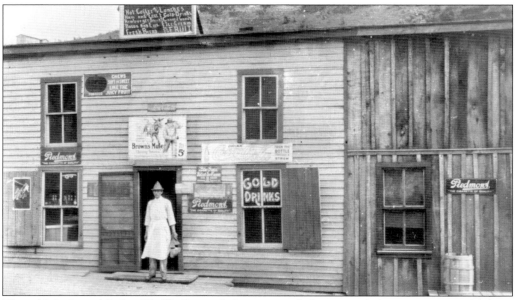

The old Indian (Cedar Bluff) General Store provided many of the necessities of life to citizens at the beginning of the 20th century, when this photograph was taken. (Courtesy of Gaynelle Thompson.)

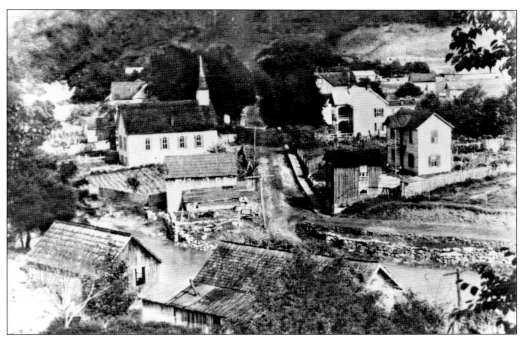

The Kentucky Turnpike wound through the western end of Cedar Bluff, shown here in the early 20th century. The Methodist church is prominently displayed in the center of the photograph. (Courtesy of Gaynelle Thompson.)

The bridge across Indian Creek in Cedar Bluff is pictured here in 1923. Many people continued to refer to the community as Indian as late as the early 20th century. (Courtesy of Gaynelle Thompson.)

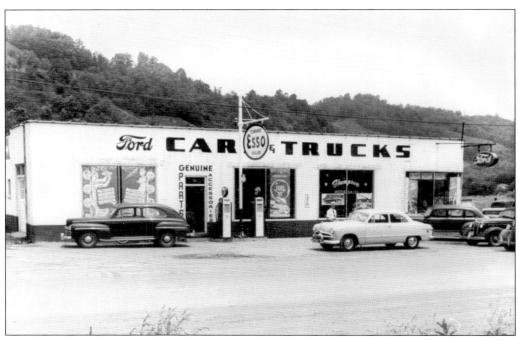

The Cedar Bluff Esso Station, shown here around 1940, was located on Main Street. The business also served as the local Ford dealership. (Courtesy of Gaynelle Thompson.)

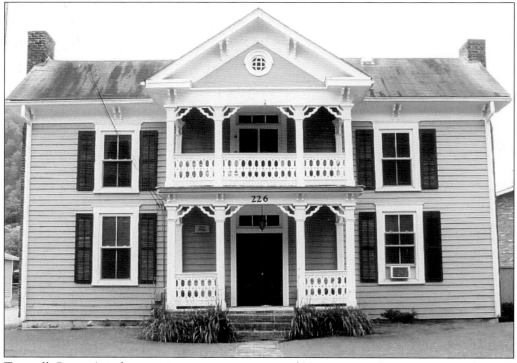

Tazewell County's only native to serve as governor of Virginia was George C. Peery, born in 1899 in this house on the Kentucky Turnpike in Cedar Bluff. (Courtesy of Terry W. Mullins.)

Four

POCAHONTAS

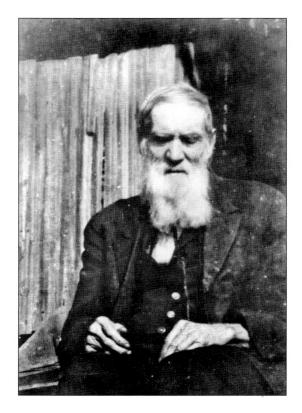

Jordan Nelson (1829–1922) was the first person to use Pocahontas coal commercially in his blacksmith shop. Nelson expanded his business, supplying coal first in saddlebags and later by the wagonload. In 1870, Nelson's coal sold for a penny a bushel. Eventually, more than 44 million tons of coal would be shipped from the original Pocahontas mines. (Courtesy of the Tazewell County Historical Society.)

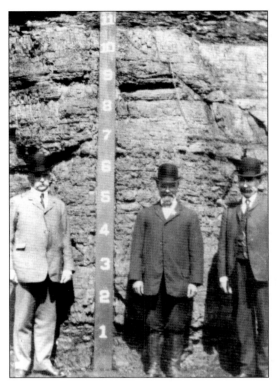

An outcropping of the Pocahontas Number 1 coal seam illustrates the unique depth of the rich Pocahontas seam coal deposits. The 10-foot marker shows evidence of this. (Courtesy of the Norfolk and Western Historical Photograph Collection at Virginia Tech.)

Dayton P. Belcher, acting superintendent of the Pocahontas Mine, indicates to William A. Fullerton (left), special agent to the president of Pocahontas Fuel Company, and M. R. Reedy, lamp attendant, the carved keystone over the entrance to the West Mine. The stonework surrounding the keystone of Pocahontas coal was done by Italian stonemasons. The stone entrance was constructed between 1907 and 1918. (Courtesy of the Tazewell County Historical Society.)

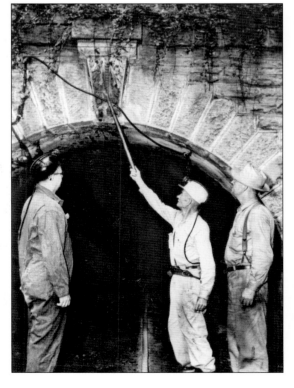

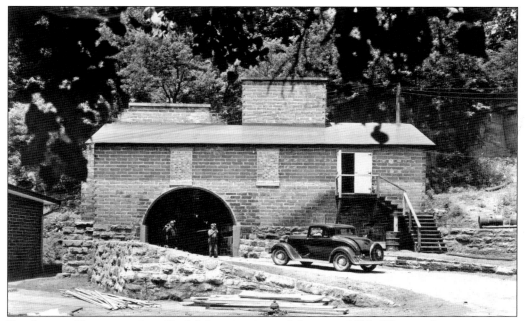

Pocahontas Demonstration Coal Mine is pictured here in 1938. This working mine was converted as a demonstration mine to better explain the process of coal mining in the great Pocahontas coal seam. (Courtesy of the Norfolk and Western Historical Photograph Collection at Virginia Tech.)

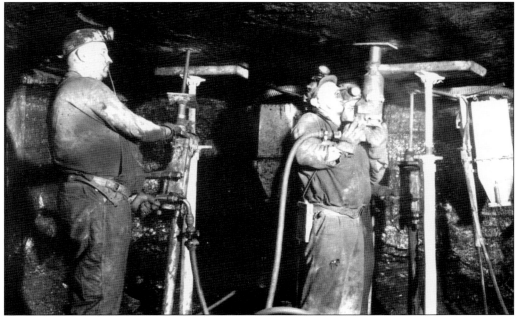

Miners are at work inside the Pocahontas Fuel Company mines at Pocahontas in 1953. Mechanization drastically changed the role of the miner, as well as the number of coal miners required to mine coal in the Pocahontas seam and throughout the country. (Courtesy of the Norfolk and Western Historical Photograph Collection at Virginia Tech.)

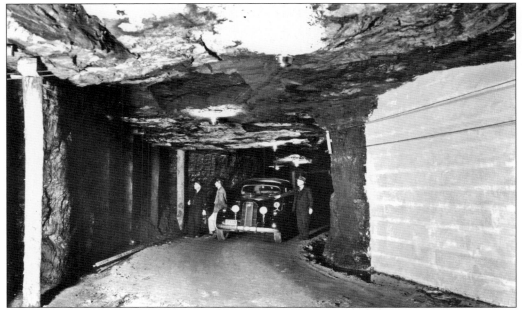

A passenger car exits Pocahontas Demonstration Coal Mine in 1938. Visitors, shown here, gain a first-hand view of a working coal mine in Pocahontas. (Courtesy of the Norfolk and Western Historical Photograph Collection at Virginia Tech.)

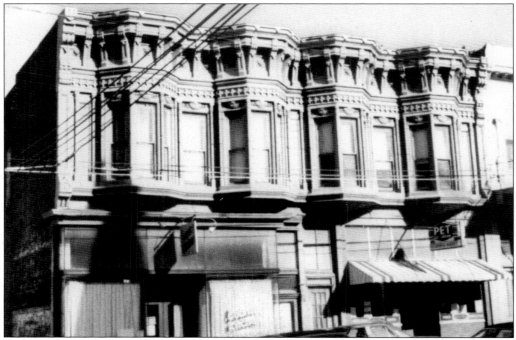

Pocahontas became a boomtown as coal production increased and more coal mines opened in the region. Pocahontas boasted the largest population of any Tazewell County town in the early 20th century. One of the many impressive downtown structures is pictured here on East Center Street. (Courtesy of the Tazewell County Historical Society.)

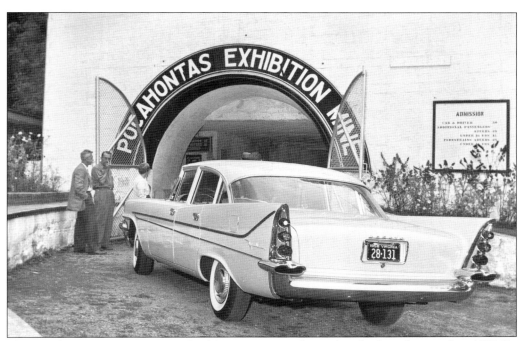

The Pocahontas Demonstration Coal Mine is pictured two decades later here with a 1958 De Soto dealer approaching the mine entrance. (Courtesy of the Norfolk and Western Historical Photograph Collection at Virginia Tech.)

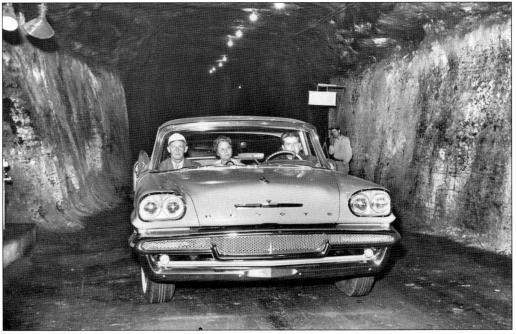

A local De Soto dealer proudly escorts guests through the Pocahontas Demonstration Coal Mine in 1958. (Courtesy of the Norfolk and Western Historical Photograph Collection at Virginia Tech.)

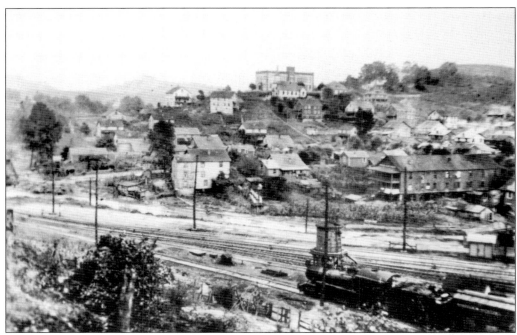

Pocahontas remained a bustling community into the mid-20th century. In the 1920s, Pocahontas was home to several thousand residents. (Courtesy of the Tazewell County Historical Society.)

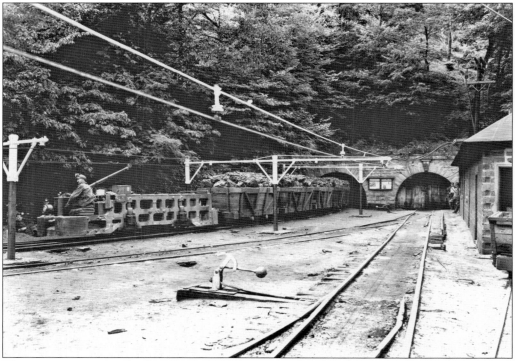

The main entrance to the Pocahontas Fuel Company's Pocahontas Mine is shown here in 1930. (Courtesy of the Norfolk and Western Historical Photograph Collection at Virginia Tech.)

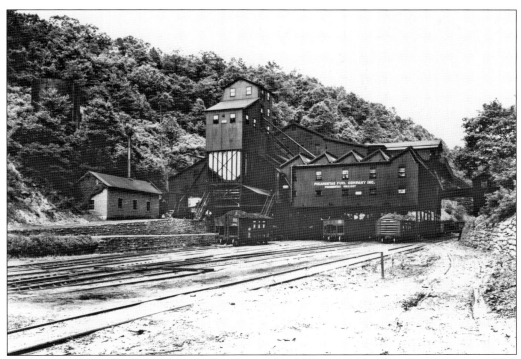

Coal cars are being loaded at the busy Pocahontas Fuel Company Tipple in Pocahontas in 1930. (Courtesy of the Norfolk and Western Historical Photograph Collection at Virginia Tech.)

The headquarters for the Pocahontas Fuel Company were located in the town of Pocahontas. The building is shown here in 1953. (Courtesy of the Norfolk and Western Historical Photograph Collection at Virginia Tech.)

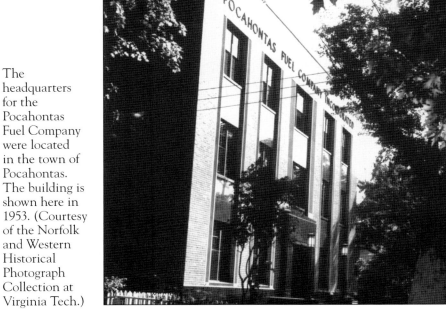

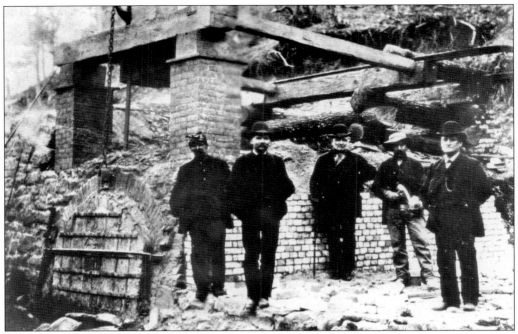

Early leaders of the Pocahontas coalfields are shown here posing in front of one of the early mine sites near Pocahontas. (Courtesy of the Norfolk and Western Historical Photograph Collection at Virginia Tech.)

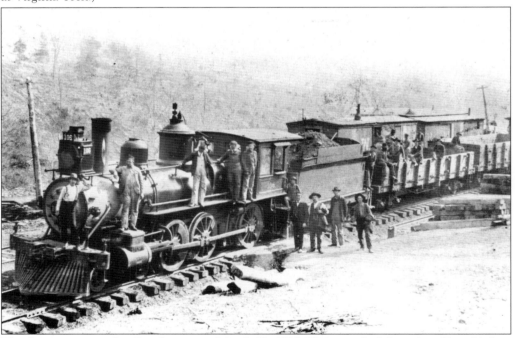

The first train arrived in Pocahontas on March 12, 1883. The arrival of the railroad heralded an extended period of growth in both coal production and the community's population. (Courtesy of the Tazewell County Historical Society.)

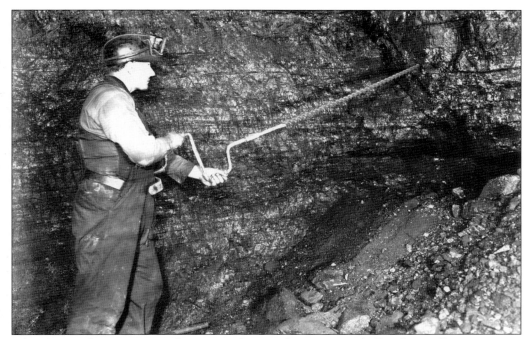

A local miner demonstrates coal-mining techniques for a visitor to the Pocahontas Demonstration Coal Mine in 1930. (Courtesy of the Norfolk and Western Historical Photograph Collection at Virginia Tech.)

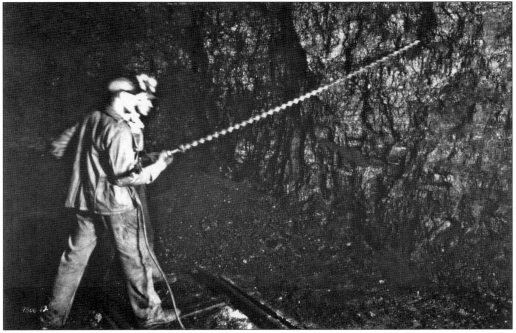

This miner demonstrates the methods used by early miners cutting into the coal seam at the Pocahontas Demonstration Coal Mine in 1930. (Courtesy of the Norfolk and Western Historical Photograph Collection at Virginia Tech.)

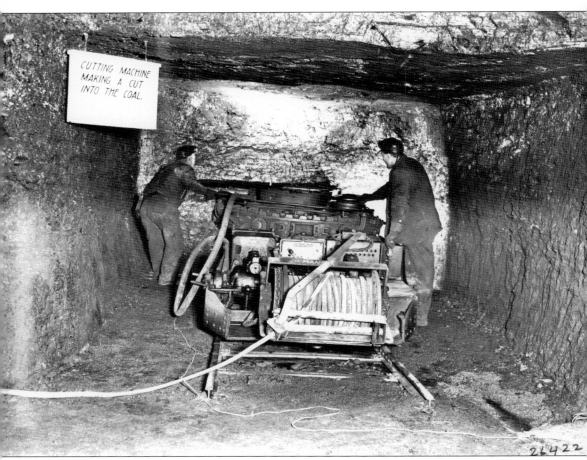

Here is a closer view of the cutting machine in Pocahontas Demonstration Coal Mine 2 in 1930. (Courtesy of the Norfolk and Western Historical Photograph Collection.)

Five

RICHLANDS

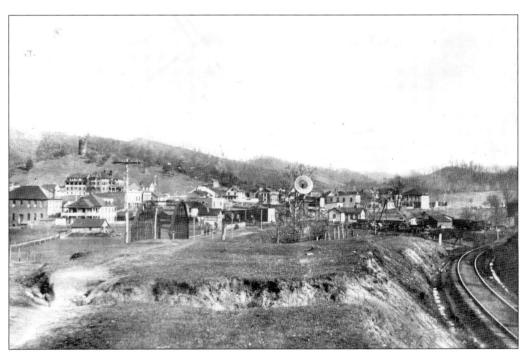

Richlands in 1908 was a developing town. Locals can easily recognize the Front Street Bridge, the 1894 school, Hotel Richlands, and Merchants and Farmers Bank. (Courtesy of Gaynelle Thompson.)

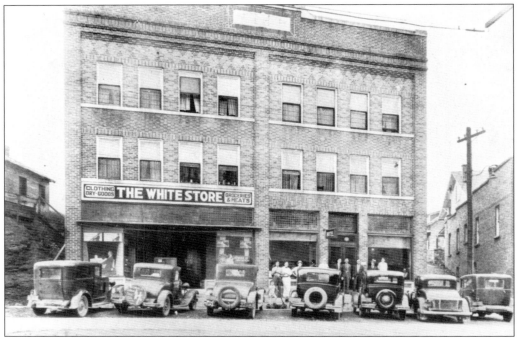

The White Store sold general merchandise and groceries. It was built in 1923 and owned by John and H. B. McGlothlin and Boss Brown. (Courtesy of Gaynelle Thompson.)

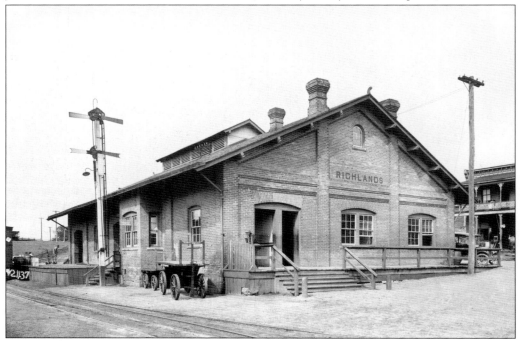

The Richlands Train Station became an important stop on the Clinch Valley Line of the Norfolk & Western Railroad. (Courtesy of the Norfolk and Western Historical Photograph Collection at Virginia Tech.)

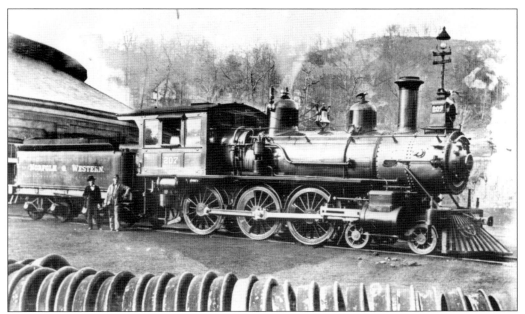

The Norfolk & Western Railway was a major factor in the development of the coalfields. This train was photographed at the Richlands station in 1890, when there were promises of creating a "Pittsburgh of the South" on the rich lands along the river. (Courtesy of Gaynelle Thompson.)

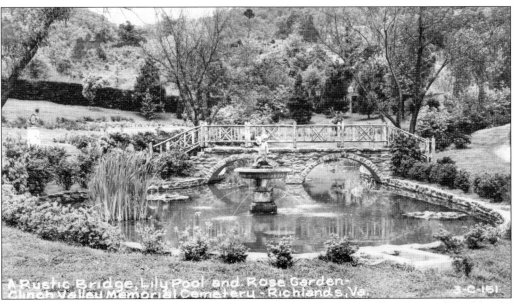

The Clinch Valley Memorial Cemetery, a tranquil addition to the town of Richlands, was a beautiful, peaceful part of the growing town in the early 20th century. (Courtesy of Gaynelle Thompson.)

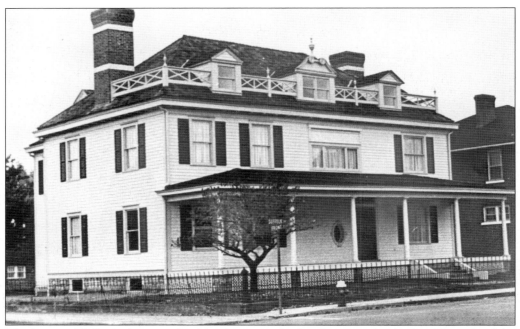

The historic Williams house in Richlands is now the headquarters for the local branch of the Tazewell County Public Library. (Courtesy of Gaynelle Thompson.)

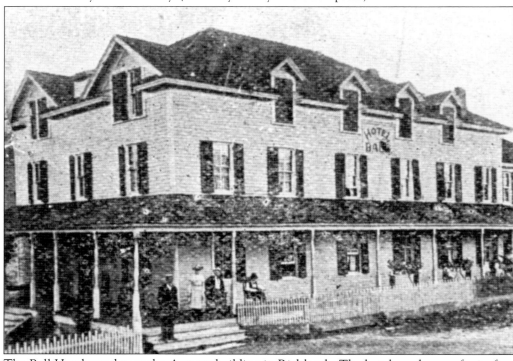

The Ball Hotel stood near the Armory building in Richlands. The hotel was known for its fine furnishings and fine hospitality. The guests on the porch seem to be enjoying a warm summer day. (Courtesy of Gaynelle Thompson.)

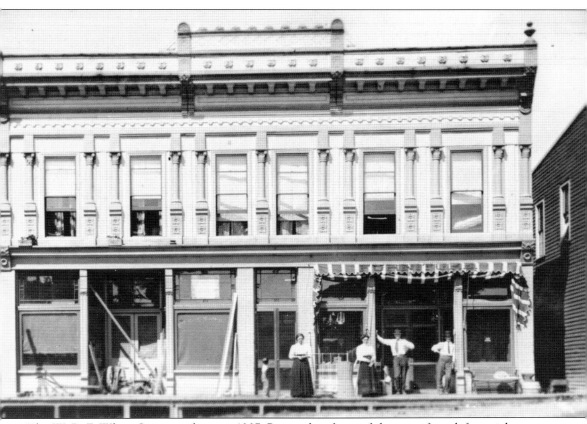

The W. B. F. White Store was busy in 1907. Pictured in front of the store from left to right are Mary (Molly), Etta, W. B. F., and John C. White. (Courtesy of Gaynelle Thompson.)

Dr. William Rees Williams, son of W. C. and Octavia E. Davis Williams, founded the Mattie Williams Hospital in Richlands. Dr. Williams married Mattie Lou Peery, daughter of Dr. James Peery and Mary Letitia Spotts Peery. (Courtesy of the Tazewell County Historical Society.)

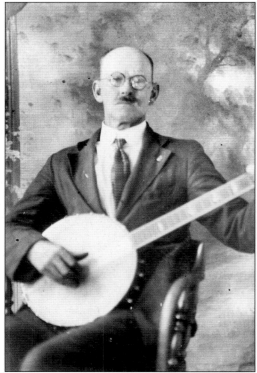

George Granville Harris (1864–1941) operated the first newspaper in Richlands close to the turn of the century. He was known as "G. G." and must have been an aspiring musician. (Courtesy of Gaynelle Thompson.)

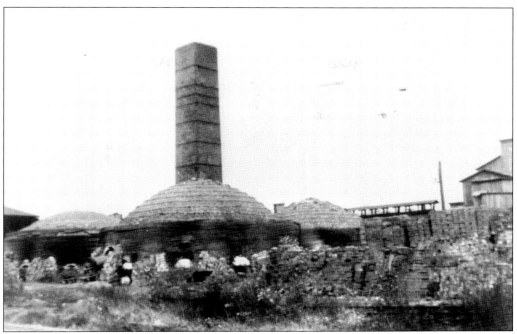

The General Shale Kiln, pictured in 1946, was once a big business enterprise in Richlands. (Courtesy of Gaynelle Thompson.)

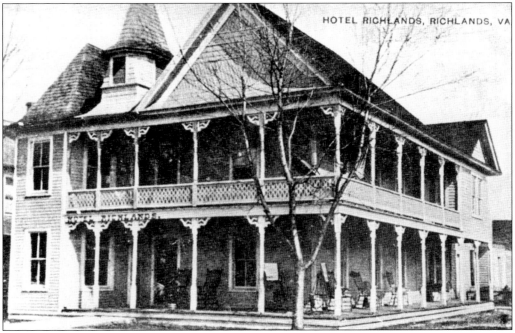

Hotel Richlands was built about 1890, just in time for the many guests who came to the growing town. It was first called Richlands Inn. The building was torn down in the early 1930s. (Courtesy of Gaynelle Thompson.)

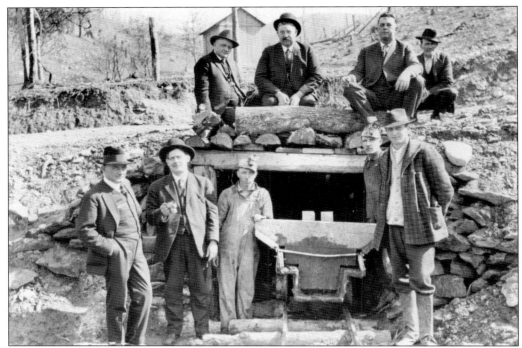

The stockholders of the Brown Hollow Mining operation are photographed in 1900. (Courtesy of Gaynelle Thompson.)

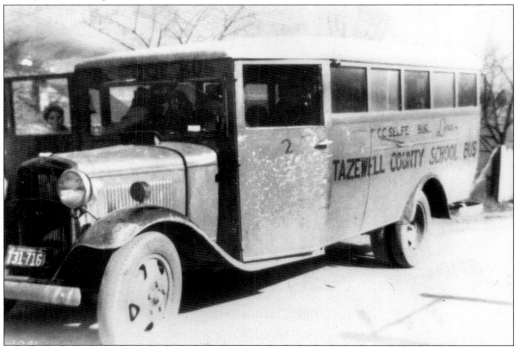

C. C. Selfe provided transportation for Richlands schools from 1935 to 1941. (Courtesy of Gaynelle Thompson.)

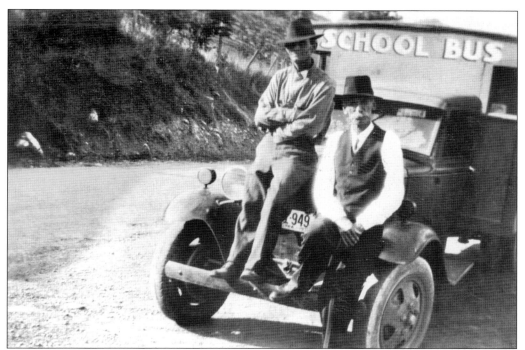

The first Maiden Spring District school bus was operated by R. L. Crawford (left) and J. T. Pruitt. (Courtesy of Gaynelle Thompson.)

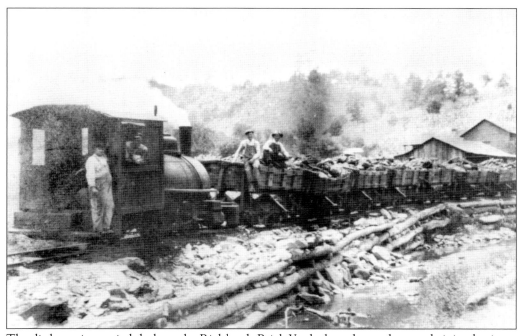

The dinky train carried shale to the Richlands Brick Yard when the yard was a thriving business in a town "on the move." (Courtesy of Gaynelle Thompson.)

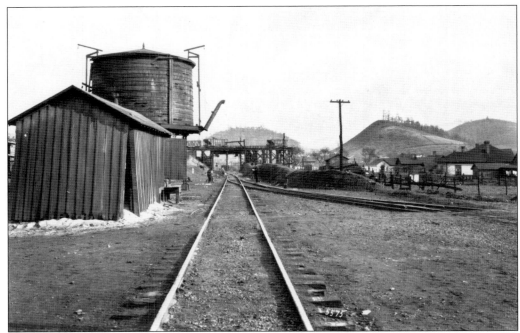

This early Norfolk & Western water tank was built in Richlands shortly after the construction of the Clinch Valley Line. (Courtesy of the Norfolk and Western Historical Photograph Collection at Virginia Tech.)

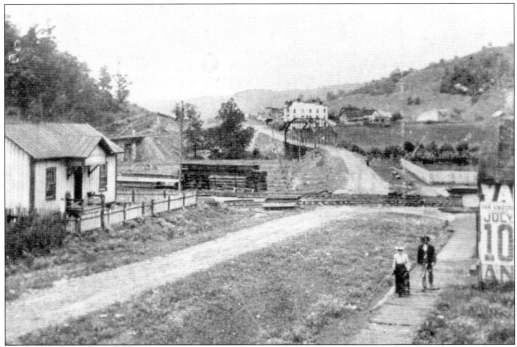

This is the center of Front Street, Richlands, around 1890. Visible is the cottage built by the railroad for the section foreman and his family. (Courtesy of Gaynelle Thompson.)

Six

COAL COMMUNITIES

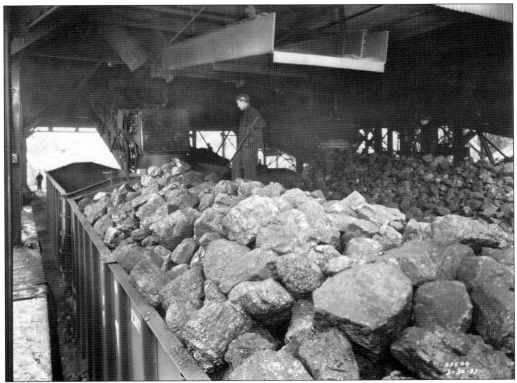

"Black Gold," or the coal of the Pocahontas coal seam, led to the birth of several new Tazewell County coal communities from Pocahontas in the east to Boissevain, Horsepen, Bishop, Amonate, Jewell Ridge, Raven, and Red Ash to the west. (Courtesy of the Norfolk and Western Historical Photograph Collection at Virginia Tech.)

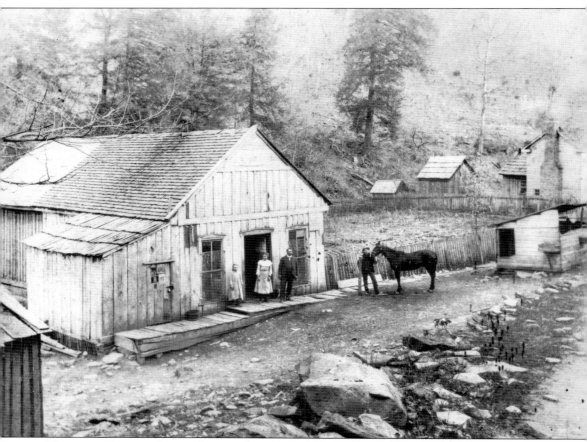

Horsepen Cove, in the north-central portion of Tazewell County, was named for the natural cove in which Native Americans corralled horses for which they had traded. Joe Hunt, his wife, and their daughter are shown in front of their Horsepen store with mail carrier Neel Murphy by his horse. Growth came to the Horsepen area thanks to the location of numerous nearby coal mines in the early 20th century. (Courtesy of the Tazewell County Historical Society.)

Cosby Ann Asbury Totten of Thompson
Valley was one of the first women to work in
the coal mines at Bishop. She began work as a
shuttle car operator in 1976. (Courtesy of the
Leslie files.)

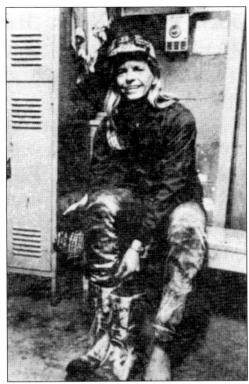

S. E. Harman of Abbs
Valley was a deputy with the
Tazewell County Sheriff's
Office for 29 years. He served
with three different sheriffs.
(Courtesy of the Leslie files.)

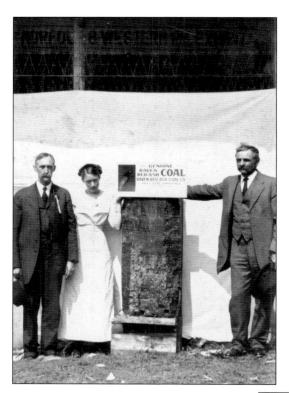

J. N. Harman (left) and Minnie Etta Harman pose with an exhibit of "Genuine Raven Red Ash Coal." An unidentified man stands to the right. The photograph was taken by Tazewell photographer A. M. Black. (Courtesy of the Tazewell County Historical Society.)

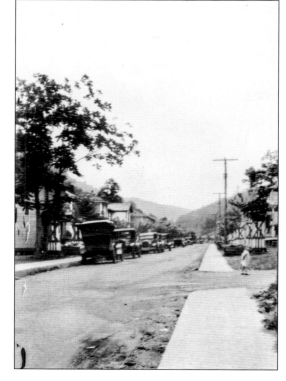

C. E. Nash photographed Main Street in Amonate in the 1920s. Amonate was renowned throughout the region as a model coal community, as evidenced by the modern homes, streets, and sidewalks. (Courtesy of the Tazewell County Historical Society.)

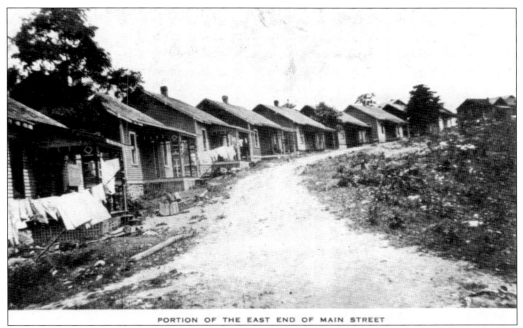

PORTION OF THE EAST END OF MAIN STREET

The eastern end of the Jewell Ridge community was illustrated on a postcard produced by the Jewell Ridge Coal Corporation in the mountaintop coal community. (Courtesy of the Tazewell County Historical Society.)

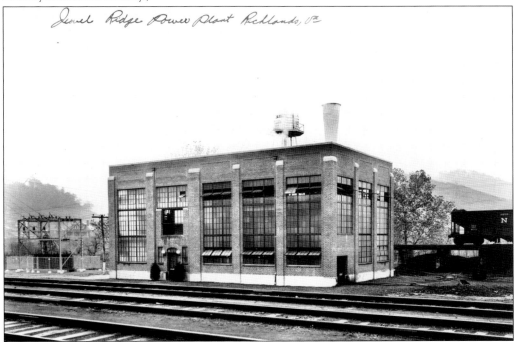

An outside view of the Jewell Ridge Power Plant is shown here in 1933. The coal company created its own electric company to run the mines and to serve the people of the coalfield community. (Courtesy of the Norfolk and Western Historical Photograph Collection at Virginia Tech.)

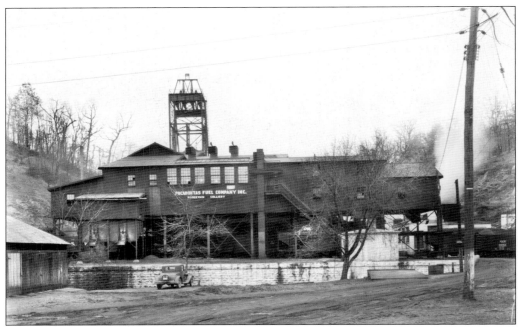

The Boissevain Tipple of the Pocahontas Fuel Company is in full-scale operation in 1931. Boissevain became another important coal community in the northeastern portion of Tazewell County. (Courtesy of the Norfolk and Western Historical Photograph Collection at Virginia Tech.)

Boissevain Commissary, of the Pocahontas Fuel Company, operates out of an impressive building in 1931. (Courtesy of the Norfolk and Western Historical Photograph Collection at Virginia Tech.)

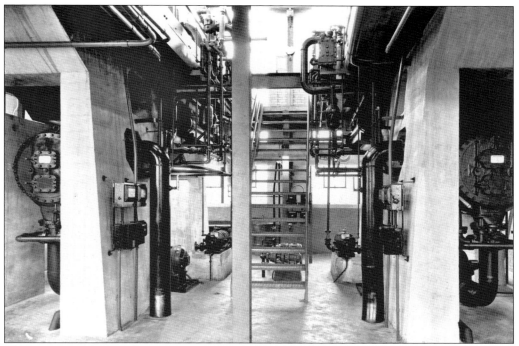

The interior of the Jewell Ridge Power Plant is illustrated here in 1933. (Courtesy of the Norfolk and Western Historical Photograph Collection at Virginia Tech.)

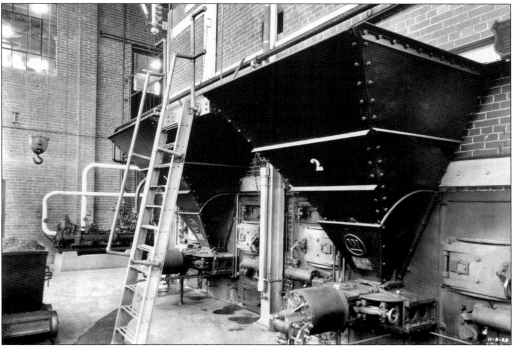

Another view of the interior of the 1933 Jewell Ridge Power Plant is shown here. (Courtesy of the Norfolk and Western Historical Photograph Collection at Virginia Tech.)

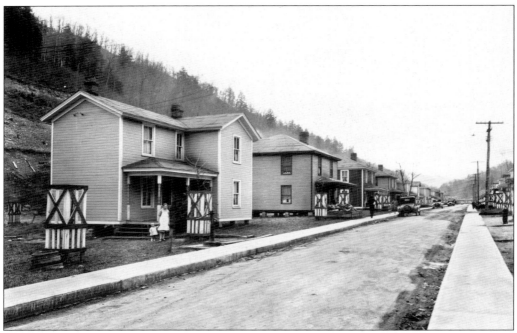

Main Street in Amonate, seen in 1929, illustrates the progressive coal community that straddled the Virginia–West Virginia state line. (Courtesy of the Norfolk and Western Historical Photograph Collection at Virginia Tech.)

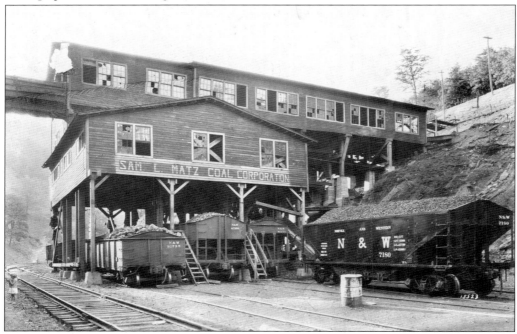

The Sam L. Matz Coal Company was also known as the Red Ash Coal Company. Located at Raven, the tipple is pictured in 1931. (Courtesy of the Norfolk and Western Historical Photograph Collection at Virginia Tech.)

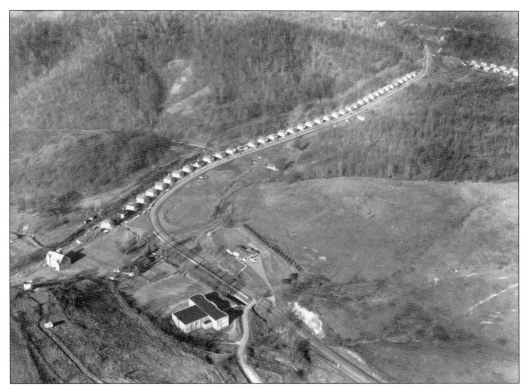

Bishop was a bustling coal community in northern Tazewell County during the 1930s and 1940s. Long Row was the home of many of the coal miners and their families in this "model" coal camp. (Courtesy of Grubb Photo.)

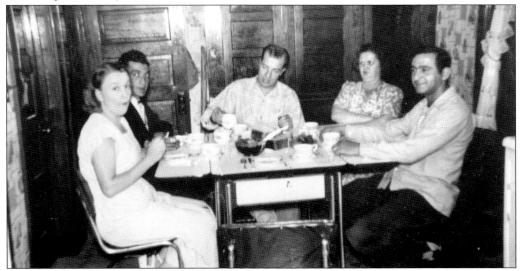

The company house was the center of activity for many coal community activities. Gathered around the dinner table here from left to right are Edythe and John Mullins, Reese Strong, and Mickey and Russell Fletcher, as they visit Reese and Sherlene Strong in their Bishop Coal Company home on Long Row. (Courtesy of Terry W. Mullins.)

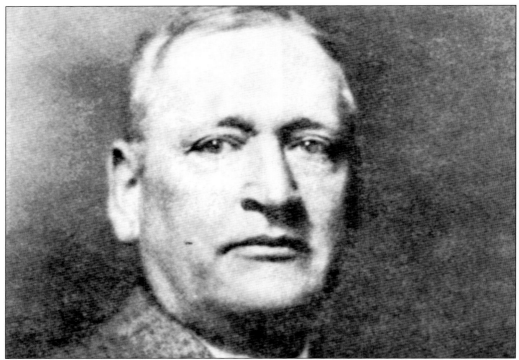

George W. St. Clair developed the coal fields in the Jewell Ridge section of Tazewell County. The town of Jewell Ridge, and the continuing coal development in the area, stand as memorials to his industry and foresight.

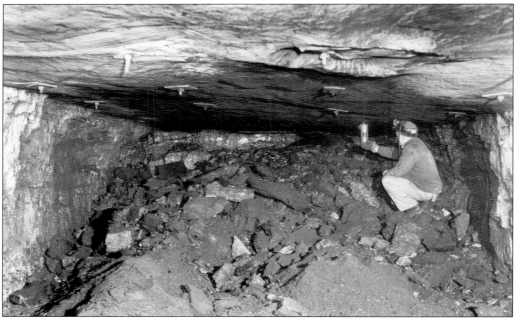

A miner examines the rich Pocahontas coal seam at the Bishop Coal Mine in 1950. (Courtesy of the Norfolk and Western Historical Photograph Collection at Virginia Tech.)

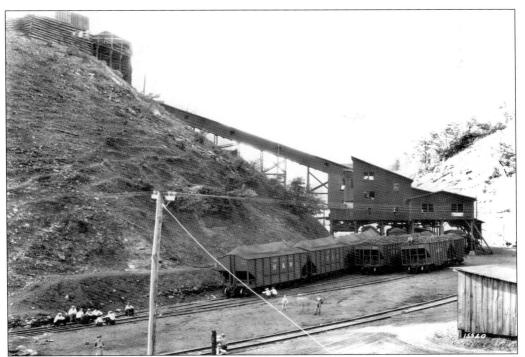

Shown here is another view of the Red Ash Coal Company Tipple at Raven in 1931. (Courtesy of the Norfolk and Western Historical Photograph Collection at Virginia Tech.)

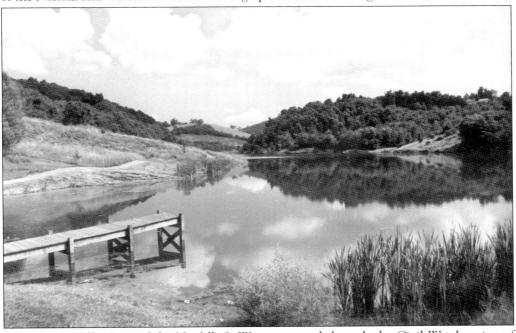

The Clinch Valley Line of the Norfolk & Western passed through the Civil War location of Georgia Camp when the railroad was constructed in 1888. Later the popular Lincolnshire Lake and Recreation Park was built on the site. (Courtesy of Bryan Warden.)

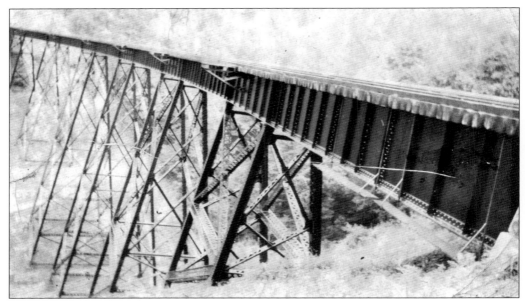

This railroad trestle was built near Amonate on the Cedar Bluff–McDowell County extension. The trestle, pictured in 1927, opened many southern West Virginia mines to the Clinch Valley Railroad Line in Tazewell County. (Courtesy of Gaynelle Thompson.)

The Jewell Ridge YMCA and other structures in the town were built by the coal company for the miners and their families in what the *Clinch Valley News*, a weekly newspaper, called a "model coal operation." (Courtesy of Gaynelle Thompson.)

Seven

FARM COMMUNITIES

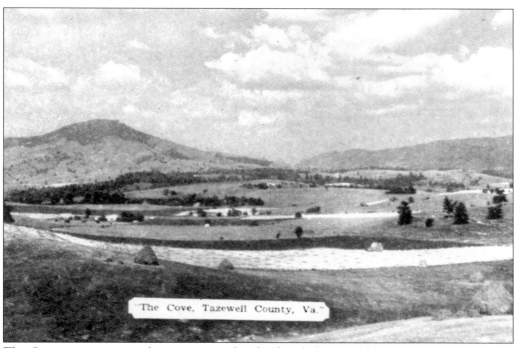

"The Cove, Tazewell County, Va."

The Cove community, with its extensive farmland and elegant old homes, is one of Tazewell County's natural treasures. (Courtesy of the Tazewell County Historical Society.)

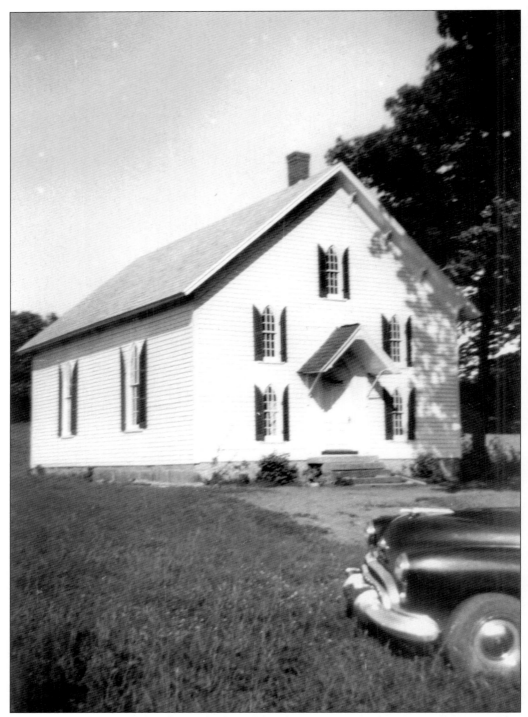

The Cove Presbyterian Church was the first of that denomination built in Tazewell County. This building was constructed in 1897, but the congregation was first organized in 1832. (Courtesy of the Tazewell County Historical Society.)

The Burkes Garden Lutheran Church, built soon after the first migration of German Lutherans into Burkes Garden in the early 19th century, was once used as a community church, with different denominations alternating Sunday worship days. It is now the only active Lutheran congregation in Tazewell County. (Courtesy of the Tazewell County Historical Society.)

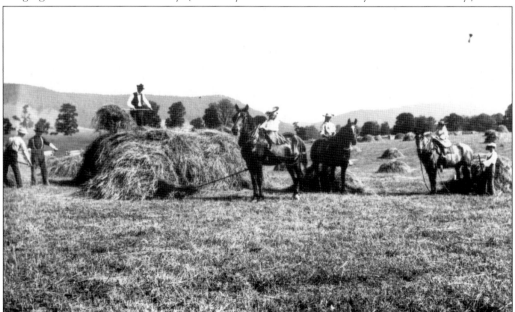

Making hay was a community undertaking in the days before farm chores were helped by machinery. This family and neighbors accomplished the task in Burkes Garden on a bright summer day. (Courtesy of the Tazewell County Historical Society.)

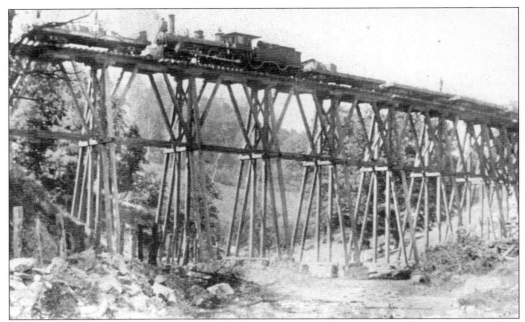

One of the first trains to travel the Clinch Valley Railroad crossed this trestle at Witten's Mill in the late 1880s. The tragic death of Mary M. Smoot and J. J. Brown occurred here in 1892 as the couple walked on the tracks en route to church at May's Chapel. Mary's foot got caught in the tracks, and J. J. Brown would not leave the helpless young girl. They embraced and were both killed by the train. (Photograph and information courtesy of Ella Greear.)

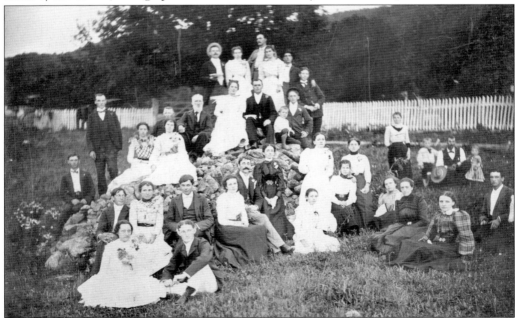

A picnic in August 1899 was a big occasion for this group at the Lettie Holmes house on the northern side of Dial Rock Mountain and just south of the western end of East River Mountain. Because of the outstanding family, this was called "Holmes Country." (Courtesy of Ella Greear.)

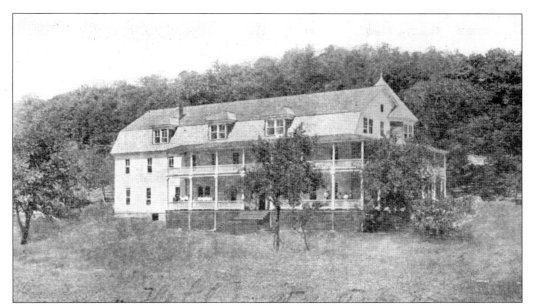

The Iron Lithia Springs hotel was a popular resort at Tip Top. It was built in the early 20th century after the 1892 discovery of the curative mineral waters close by containing lithia, iron, magnesium, and potassium. The hotel patrons were met by a horse and carriage at the Tip Top train station, known then as the highest point on the Norfolk & Western line east of the Rockies. (Courtesy of Ella Greear.)

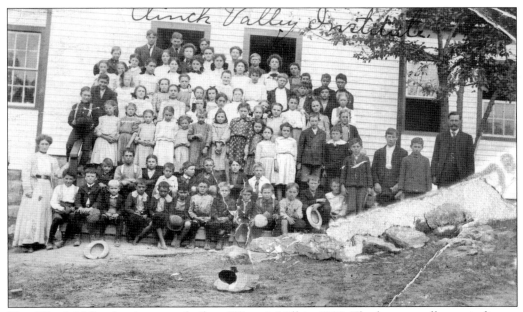

The Clinch Valley Institute was built at Witten's Mill in 1909. The large enrollment indicates the great number of people who lived in the Witten's Mill area at the beginning of the 20th century. (Courtesy of the Tazewell County Historical Society.)

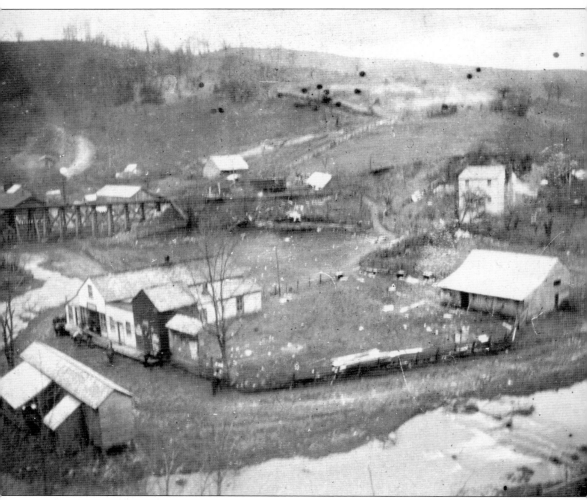

The Witten's Mill community is pictured about 1900 with the first retail store and the old Smoot home, which burned in 1967. The tannery can be seen beyond the railroad bridge, and to the far left is the Franklin Howard home. (Courtesy of Ella Greear.)

Thomas W. Witten (1821–1905) built the well-known Witten's Mill around 1870 with his son-in-law, Richard Smoot. He also gave his name to the community where some of his descendants still live. The mill was dismantled in 1946. (Courtesy of Ella Greear.)

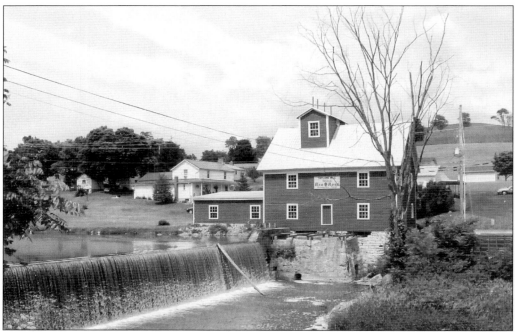

Taylor's Mill at Maxwell follows the first mill recorded at the site, which was built in 1828. It is one of the most picturesque sites in Tazewell County, and through the years, it has supplied customers with fine flour, water-ground corn meal, and ground feed for livestock. Walter Taylor operated the mill from 1946 until it closed in 1968. (Courtesy of Terry W. Mullins.)

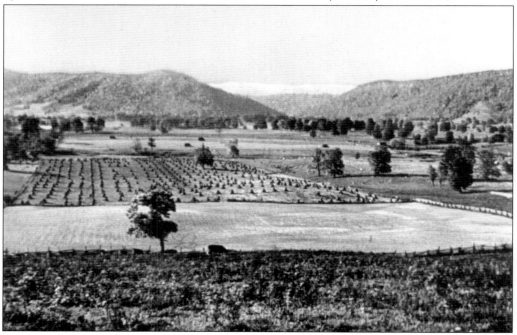

The fertile Tazewell County farmlands look promising on a spring day in Burkes Garden. (Courtesy of the Tazewell County Historical Society.)

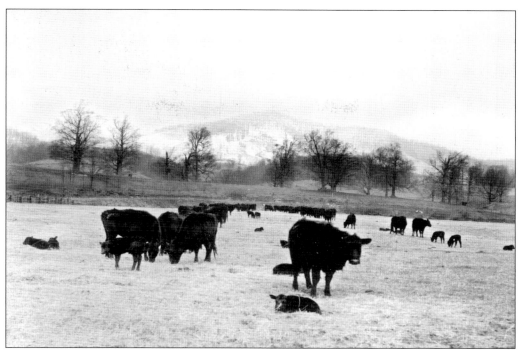

A Burkes Garden Angus herd is pictured in 1933. (Courtesy of the Norfolk and Western Historical Photograph Collection at Virginia Tech.).

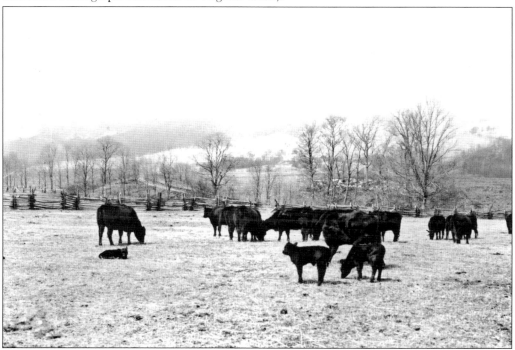

Winter feeding is in progress on the Moss farm in Burkes Garden in 1953. (Courtesy of the Norfolk and Western Historical Photograph Collection at Virginia Tech.)

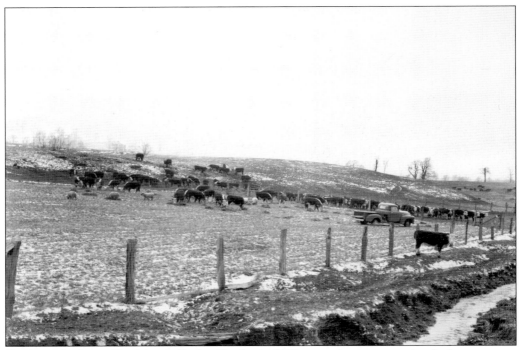

Cattle on the farm of Joe Moss in Burkes Garden in 1953 are too hungry to notice the lone escapee. (Courtesy of the Norfolk and Western Historical Photograph Collection at Virginia Tech.)

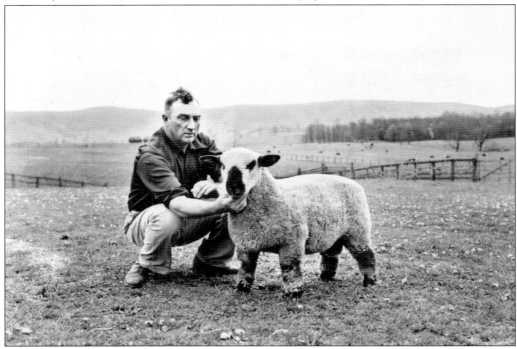

Joe Moss of Burkes Garden is pictured at the Eastern Stud Ram Sale in 1951. (Courtesy of the Norfolk and Western Historical Photograph Collection at Virginia Tech.)

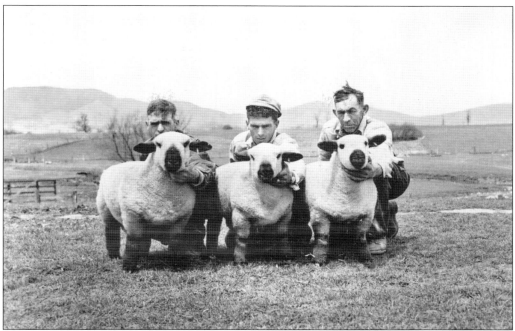

Burkes Garden sheep are shown by Marvin Meek (left), Alex Meek (center), and J. McFarland. (Courtesy of the Norfolk and Western Historical Photograph Collection at Virginia Tech.)

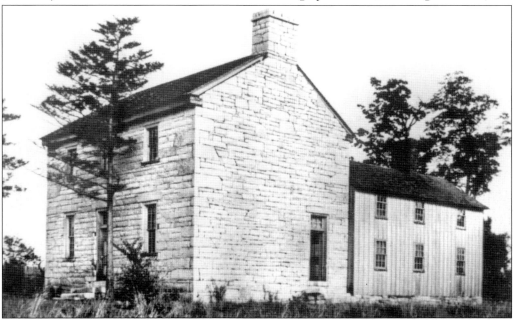

Peter Gose built this stone house in Burkes Garden in 1812. Two other stone houses were built about that time: one at North Tazewell and one at Maxwell. The Burkes Garden house later belonged to Capt. Tom Peery III and to the Lineberry family. Legend says the Burkes Garden house is haunted by a baby who cries under the hearth at midnight. (Courtesy of the Tazewell County Historical Society.)

Clear Fork Older Rural Youth Club in 1952 included, from left to right, (first row) Roy Godsey, assistant Tazewell County farm agent; and Mrs. Bill Gregory; (second row) Luke Russell, Tazewell County farm agent; Joe Muss Pruett; Bill Gregory; and W. W. Eure, Older Rural Youth specialist. (Photo is courtesy of Norfolk and Western Photograph Collection at Virginia Tech.)

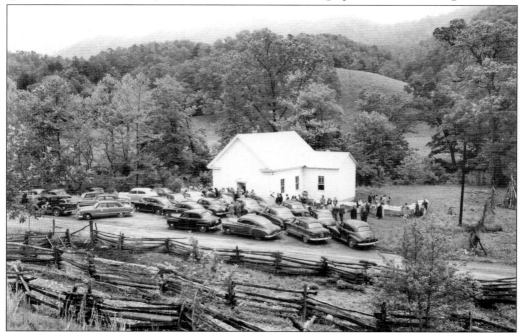

In 1950, the area home extension agents met at Crabtree Chapel in Freestone Valley. (Courtesy of the Norfolk and Western Historical Photograph Collection at Virginia Tech.)

Eight

RAILROAD COMMUNITIES

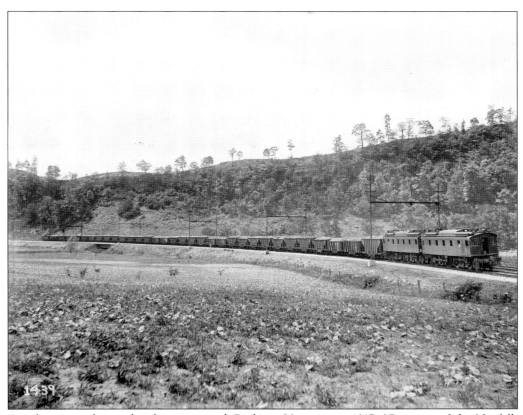

An electric coal train heads east toward Graham, Virginia, in 1917. (Courtesy of the Norfolk and Western Historical Photograph Collection at Virginia Tech.)

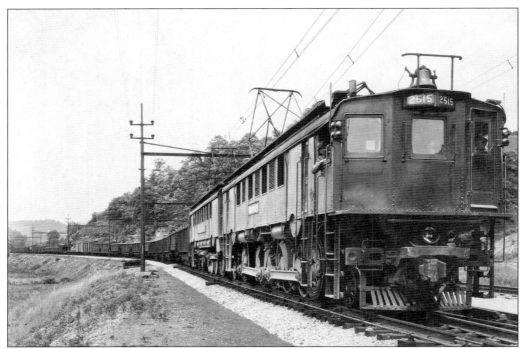

This close-up view from 1917 shows an electric coal train traveling east from Tazewell toward Graham on the Clinch Valley Line. (Courtesy of the Norfolk and Western Historical Photograph Collection at Virginia Tech.)

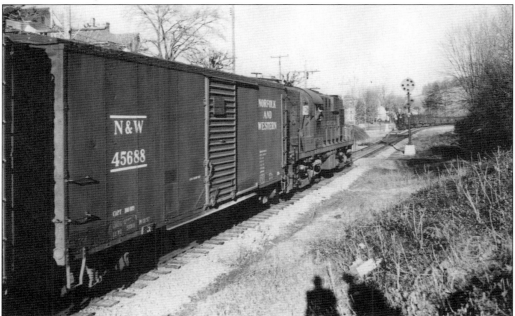

Diesel trains pass each other near Maxwell in 1959. The diesel replaced older steam-powered trains by the mid-20th century. (Courtesy of the Norfolk and Western Historical Photograph Collection at Virginia Tech.)

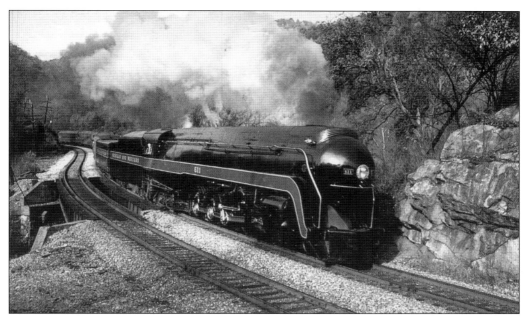

The Norfolk & Western Locomotive Number 611 provided passenger rail service up and down the Clinch Valley Line running the entire length of Tazewell County from Bluefield to Raven. (Courtesy of the Tazewell County Historical Society.)

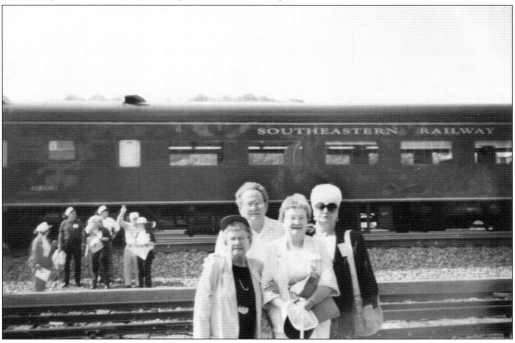

The Norfolk & Western Railroad's successor, Norfolk Southern, sponsored rail excursions in Tazewell County into the second half of the 20th century. Euna Lee and Harry Allen, Evelyn White, and Edythe Mullins prepare to board the excursion that will take them down the Clinch Valley Line from Bluefield through Tazewell to Cedar Bluff. (Courtesy of Terry W. Mullins.)

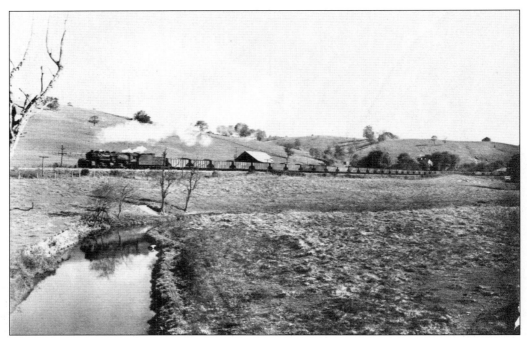

A steam engine races west down the Clinch Valley. This steam-powered locomotive nears Witten's Mill in 1951. (Courtesy of the Norfolk and Western Historical Photograph Collection at Virginia Tech.)

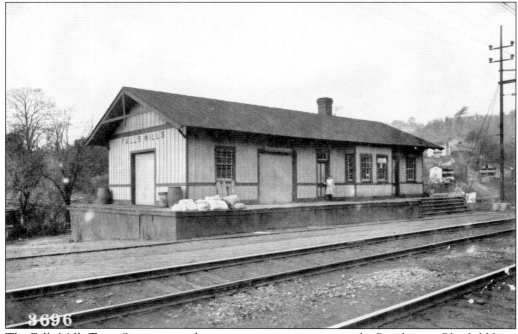

The Falls Mills Train Station served as a major stopping point on the Pocahontas-Bluefield Line of the Norfolk & Western Railway. (Courtesy of the Norfolk and Western Historical Photograph Collection at Virginia Tech.)

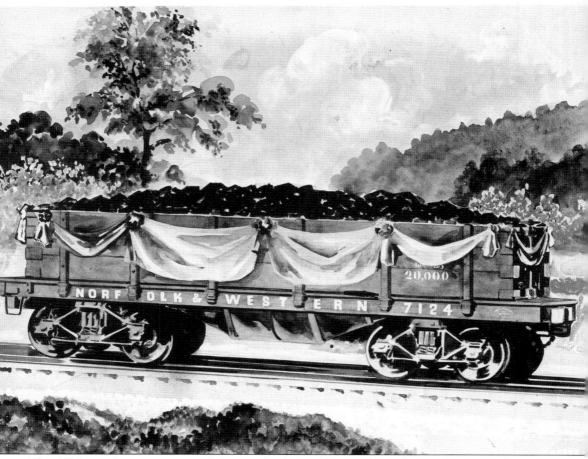

This 1938 artist's representation illustrates the first coal car to leave the Pocahontas coalfields. The first coal was shipped from the area on March 12, 1883, beginning the development of the massive Pocahontas coalfields of Tazewell County and the region. (Courtesy of the Norfolk and Western Historical Photograph Collection at Virginia Tech.)

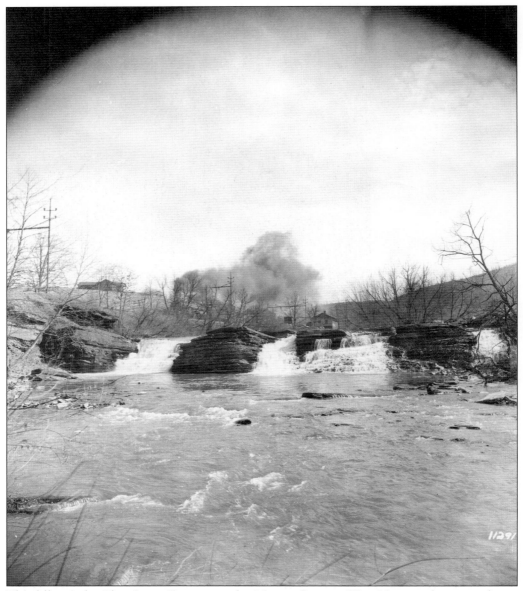

The falls on the Blue Stone River near the Mercer County, West Virginia, line served as a natural dam for a local mill. As a result, the community, and later the railroad stop, became known as Falls Mills. (Courtesy of the Norfolk and Western Historical Photograph Collection at Virginia Tech.)

An important stop on the Clinch Valley Line west of Tazewell was Maxwell. The early Maxwell Train Station is shown here in 1910. (Courtesy of the Norfolk and Western Historical Photograph Collection at Virginia Tech.)

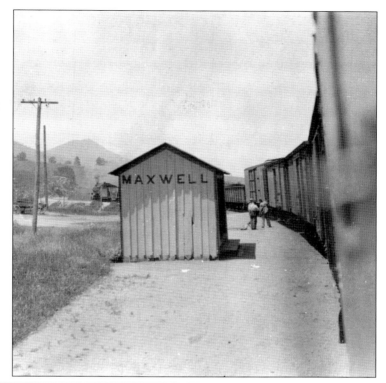

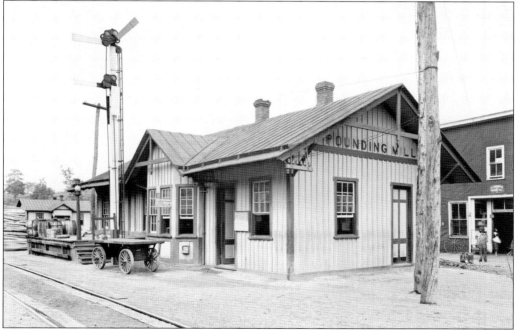

Not far west of the Maxwell Station was an even busier stop on the Clinch Valley Line at Pounding Mill. Pounding Mill also became the home of an important rural post office. (Courtesy of the Norfolk and Western Historical Photograph Collection at Virginia Tech.)

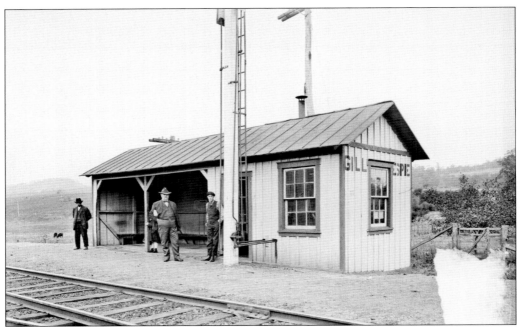

The Gillespie Shelter Shed on the Clinch Valley Line was located just west of Pounding Mill on the Norfolk & Western Railway. (Courtesy of the Norfolk and Western Historical Photograph Collection at Virginia Tech.)

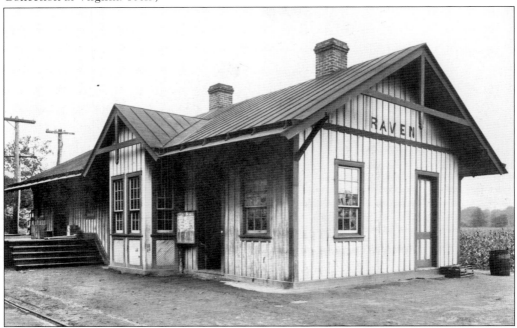

The Raven Train Station, pictured here in 1917, was the last stop on the Clinch Valley Line heading west. Located near the Russell County line, Raven became a bustling railroad and business community. (Courtesy of the Norfolk and Western Historical Photograph Collection at Virginia Tech.)

Nine

TAZEWELL COUNTY'S BEAUTY

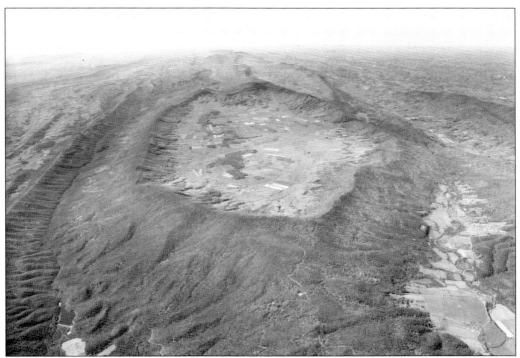

An aerial view of Burkes Garden emphasizes the natural bowl that has fascinated geologists since its discovery by James Burke and other hunters in 1748. The community was later settled by German Lutherans whose descendants still farm the fertile lands. A popular name for the unique basin, surrounded by mountains, is "God's Thumbprint." (Courtesy of Grubb Photo.)

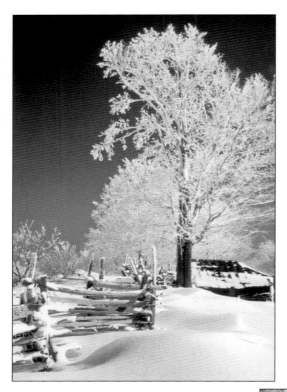

Winter in Tazewell County sometimes creates a fairyland of icy beauty. The rail fences can be seen on many livestock farms. In Tazewell County, the "stake and rider" fences are well known for their strength and unique design. (Courtesy of Hal Brainerd.)

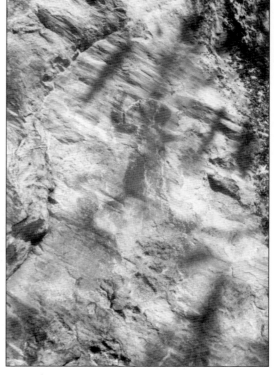

The native paintings on Tazewell's Paintlick Mountain remain a mystery. The locale was a pathway for the early hunters through the Tazewell area, and some experts believe the paintings marked an important route. They are still visible in 2005, but some of the figures are fading because of time and pollution. The paintings have been studied through the years by experts from the Smithsonian and other national museums. (Courtesy of Terry W. Mullins.)

The Rees Tate Bowen family is shown here at their Maiden Spring home, where seven generations of the Bowen family have farmed and cared for their large land holdings since 1772. Now there is a young Rees Tate Bowen VIII living at the historic home. Pictured from left to right are George Bowen, Tommy Bowen, Mrs. Bowen, Rees Tate Bowen VI, and Rees T. Bowen VII. (Courtesy of the Leslie files.)

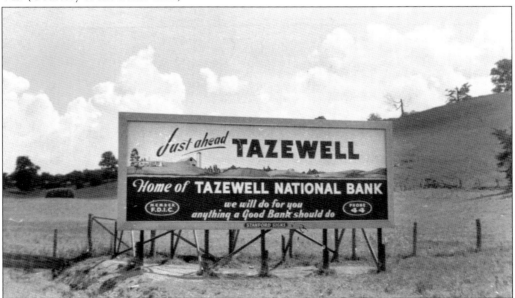

A "Welcome to Tazewell" sign greeted visitors to the beautiful scenery around the Tazewell County seat. This welcome met visitors arriving on U.S. 19-460 from the east in 1956. (Courtesy of Terry W. Mullins.)

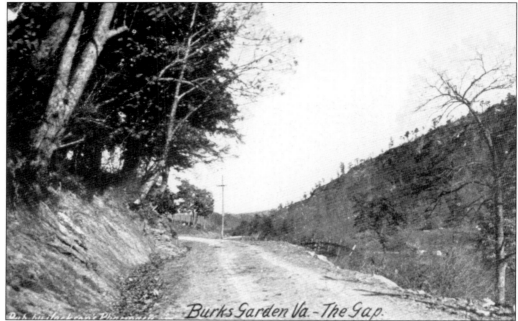

The Burkes Garden Gap, seen about 1915, shows the narrow road into the mountain community. Today the road is twice as wide and the bank is twice as high. The original road through the gap is believed to have followed animal trails. (Courtesy of the Leslie files.)

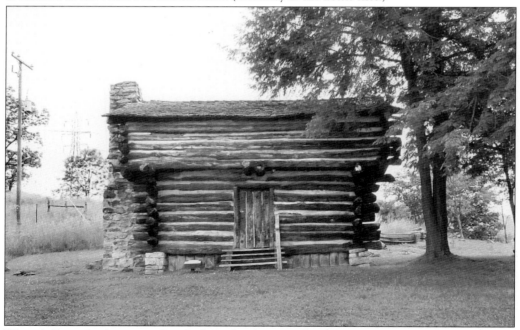

Witten's Fort, also known as Big Crab Orchard Fort, still guards the lands of the first settlers at Pisgah. Thomas Witten obtained land here in 1771 and built the fort as a neighborhood place of refuge. It was garrisoned in Dunmore's War in 1774. Today it is a tourist attraction adjacent to the Historic Crab Orchard Museum. (Courtesy of the Leslie files.)

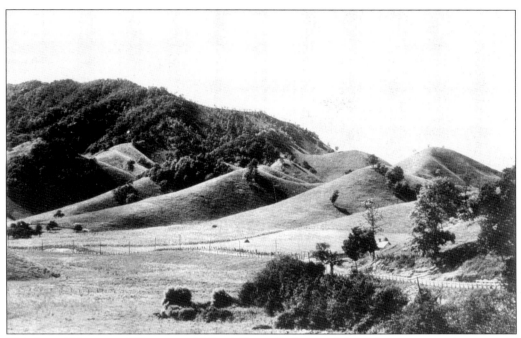

This beautiful scene of Thompson Valley hills reminds one of the unknown poet who wrote, "I stared at the hills of home and found a perfect solitude." (Courtesy of Gaynelle Thompson.)

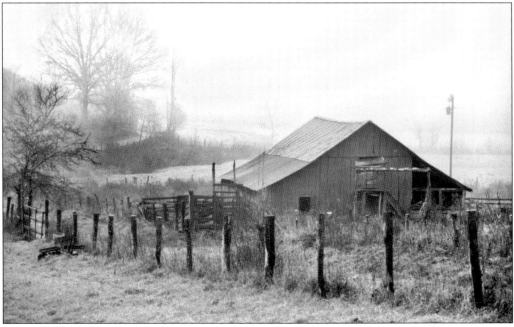

Tazewell County barns—some modern, others old and a little tired—dot the landscape with a strength that comes with years of usefulness, in good and bad times, in summer and winter, through generations who grow and change in their shadows. (Courtesy of Hal Brainerd.)

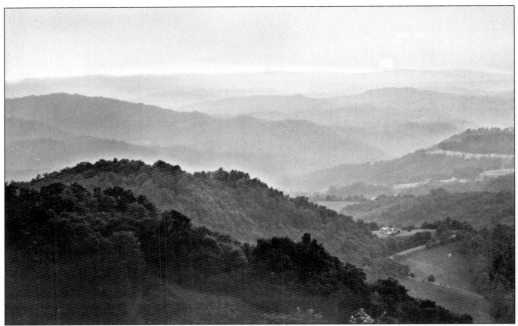

Sunset in the Tazewell County mountains brings a mellow glow to the peaks and sky that may forecast a bright day tomorrow. In this picture, five mountain ranges can be counted, perhaps reaching into West Virginia and Kentucky. It is from the top of Stoney Ridge, looking into the Bishop area. (Courtesy of Hal Brainerd.)

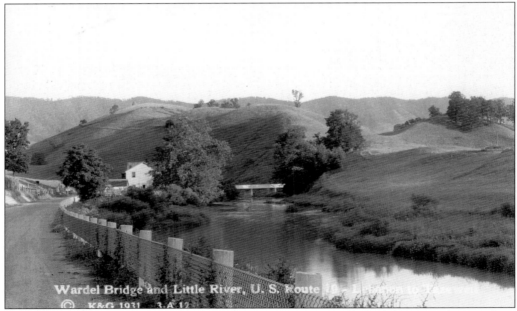

Wardel Bridge and Little River, U. S. Route
© K&G 1931 3.A.12

Wardell Bridge and Little River create a tranquil picture, especially for fishermen who have long enjoyed this spot. Today business growth and traffic have changed the terrain some, but there is still a gentle beauty in this special corner of the county. (Courtesy of the Tazewell County Historical Society.)

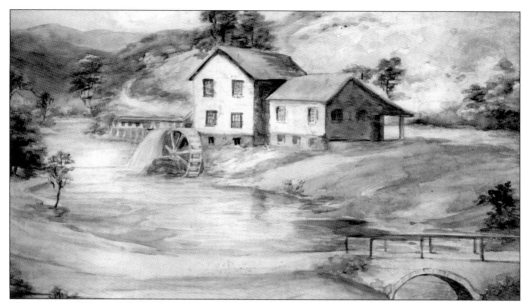

The original Witten's Mill changed as time moved on, but the site remained a favorite for artists until the structure was dismantled. The mill was built in 1872 by Thomas Witten, a great-grandson of the first permanent settler at Pisgah. It was later owned by his son, Alex Witten. This painting was the work of an unknown Tazewell visitor who used what remained of the old mill and pictures of the earlier site to create this authentic representation. (Courtesy of the Leslie files.)

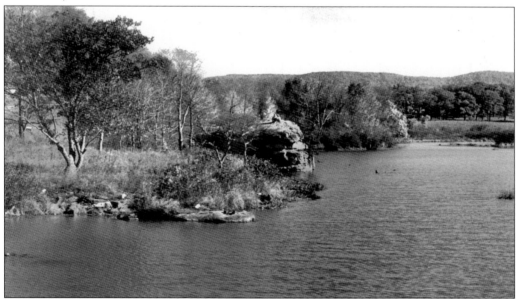

The mill dam at Burkes Garden is the first thing many visitors to the community see, and its unique beauty impresses those who remember the days of important mills and those who can imagine the former days. The large rock is a favorite place for hikers, and at one time it was privately owned by a family who liked the solitude of the Burkes Garden basin. (Photograph by Andy Larimer.)

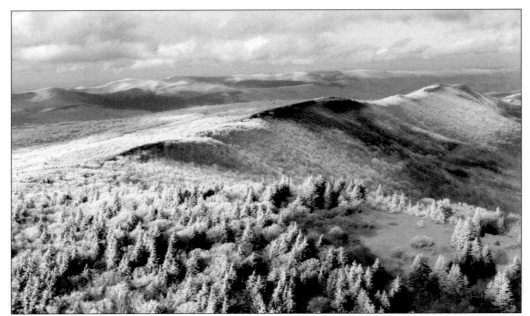

Beartown Mountain, at 4,705 feet, is the third-highest point in Virginia. The pilot-photographer seems to skim the top of the mountain range on the western edge of Burkes Garden. Because of the elevation, there are diverse plant and animal species found on Bear Town. These include golden eagles, Beartown beetles, red spruce, and sphagnum moss. (Courtesy of Grubb Photo.)

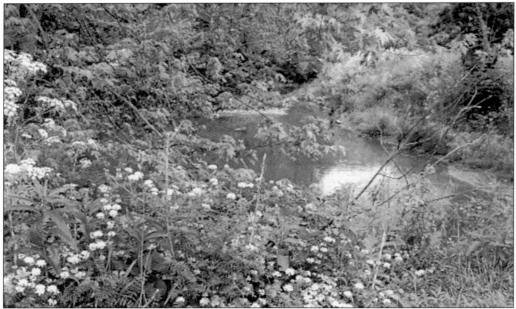

The headwaters of the Clinch River rise in Tazewell County, and its two forks unite in the Four Way section of Tazewell. From Tazewell, the Clinch River flows southwest to Richlands, Raven, and then into Russell, Wise, and Scott Counties, and finally into Tennessee, where it enters the Norris Dam Lake. This scene pictures the origin of the Clinch River near Tazewell's Long John Silver's restaurant. (Courtesy of Terry W. Mullins.)

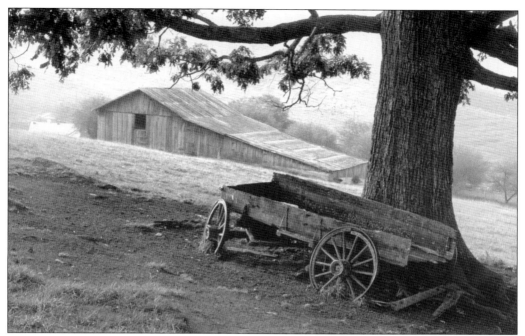

The barn is full, the wagon is on its last wheels, and the summer day is lazy on this Mud Fork farm. (Courtesy of Hal Brainerd.)

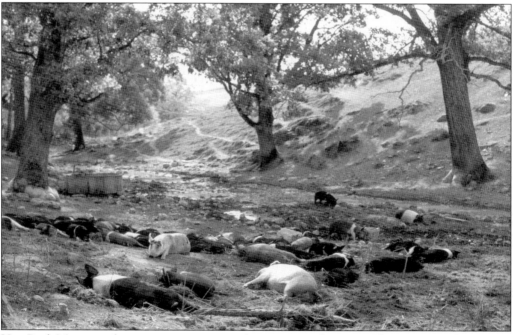

Hog Back Mountain lives up to its name on a hot summer afternoon. The name may have come from an early family who lived in the area. It is one of the most interesting parts of the Cove community. (Courtesy of Hal Brainerd.)

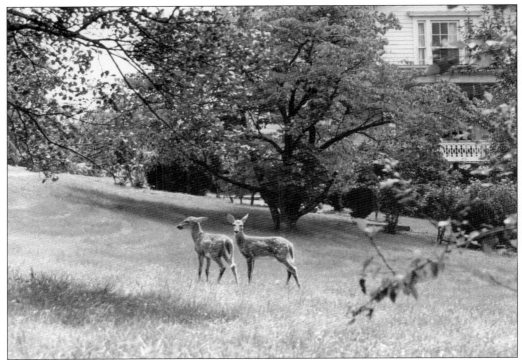

Deer on this Marion Avenue lawn in Tazewell are among the many roaming throughout the area. Only in the past few years have deer become a common sight within the residential sections of the county. (Courtesy of Bryan Warden.)

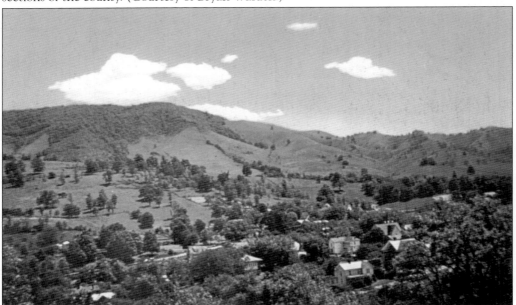

A postcard scene shows Wynne's Peak above the town of Tazewell. Wynne's Peak, usually called "the Peak," can be climbed from the town of Tazewell or from Thompson Valley. Either route is a challenge for the hiker. (Courtesy of the Tazewell County Historical Society.)

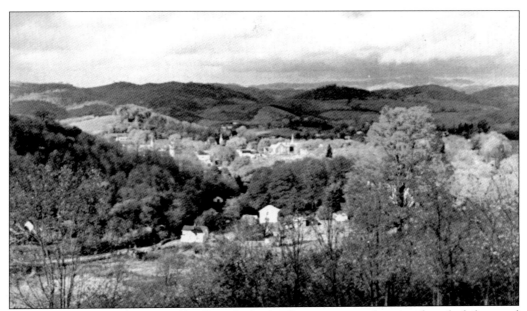

This view of the town of Tazewell is from the Peak. This summit is a favorite place for hikers and for those who enjoy the beautiful view from the top of the mountain. (Courtesy of the Tazewell County Historical Society.)

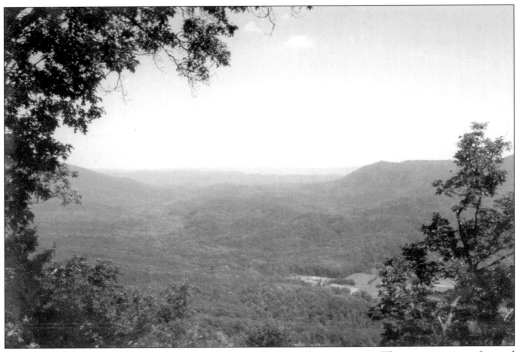

This view looks into Roaring Fork from the top of Clinch Mountain. These mountains formed a barrier for the first adventurers who explored these forests and beyond into Smyth County and the distant Blue Ridge. (Courtesy of Bryan Warden.)

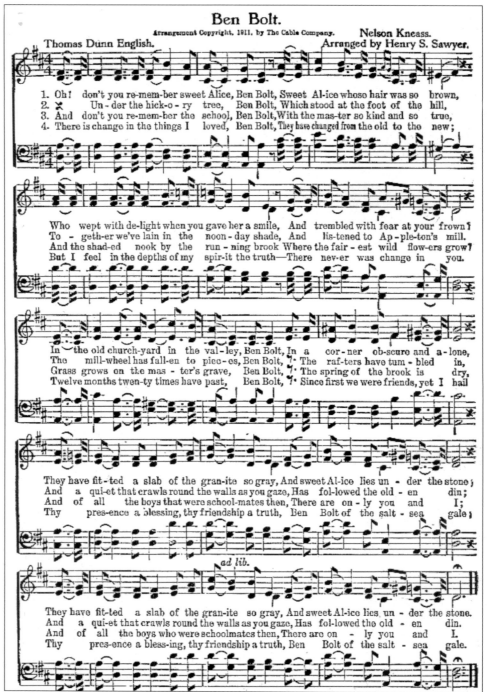

Thomas Dunn English wrote the lines including "Don't you remember Sweet Alice, Ben Bolt?" at the Peery-Wynne homestead (now owned by Scott Cole), one of the first brick homes built in Tazewell. The area is presently named "Ben Bolt" in honor of the poem, which gained an international reputation. (Courtesy of Terry W. Mullins.)

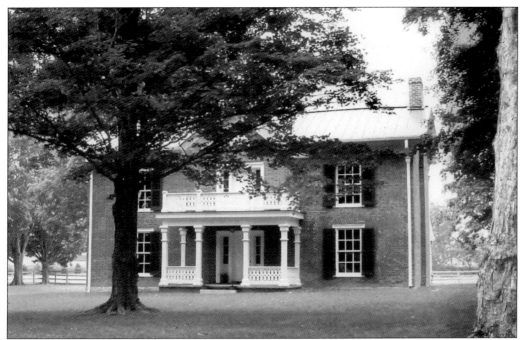

The Ben Bolt house is located on the east end of Tazewell near the present-day Tazewell Community Hospital. Dr. Thomas Dunn English wrote the world-famous poem "Ben Bolt" while visiting his friend, Capt. W. E. Peery, at his ancestral home in Tazewell in 1842. The poem speaks of "Sweet Alice" who, according to tradition, was young Alice Wynne, a relative of the Peery family. (Courtesy of Terry W. Mullins.)

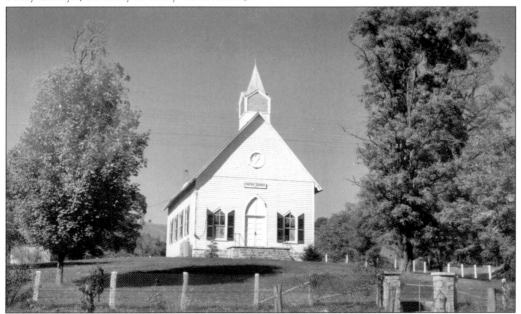

Organized in 1793, the present Pisgah Church structure, shown here in 1950, is also one of the oldest buildings in Tazewell County. (Courtesy of Grubb Photo.)

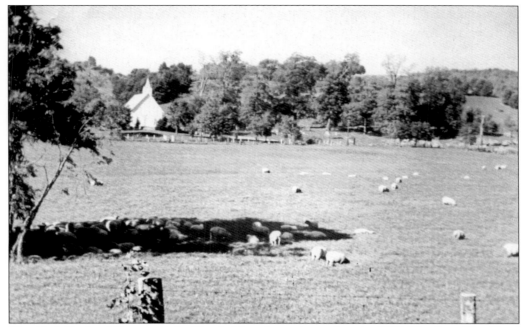

The Crab Orchard Tract and the Pisgah Church are shown here in 1960. The Late Woodland Indian Dig and the Tazewell Bypass would later occupy this tranquil pastoral setting in front of the church. (Courtesy of the Ella Greear files.)

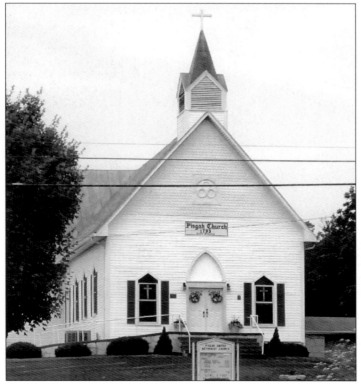

Pisgah United Methodist Church is the oldest church congregation in Tazewell County. The present structure is the third building. The original church was located on the north side of the Clinch River. (Courtesy of Terry W. Mullins.)

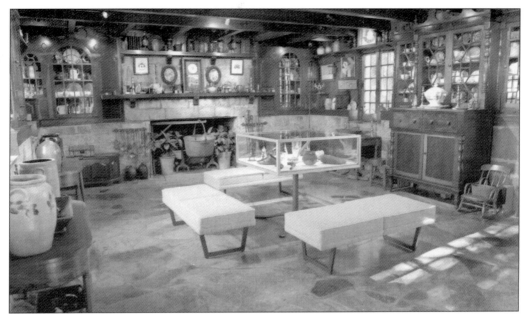

The Higginbotham Museum contains artifacts collected by the late Jeff Higginbotham. The collection is housed in the cabin belonging to the early settler Moses Higginbotham. The museum is now part of the Higginbotham House and Museum operated by a nephew, Rick Fisher. (Courtesy of Grubb Photo and Rick Fisher.)

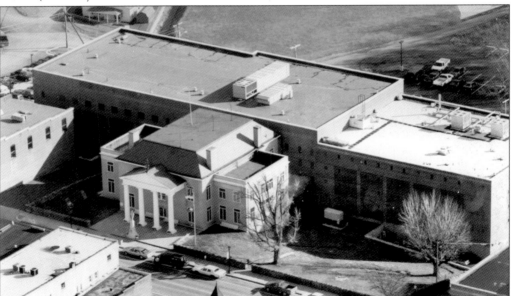

The old and new Tazewell County courthouses form a unique aerial view. The renovated 1913 structure with the Confederate monument faces Main Street, and the modern construction, which includes new offices, courtrooms, and the jail, faces Court Street to the rear. The addition was completed in 2001. The first courthouse, constructed shortly after 1800, was a log building. The next courthouse was built in 1830 on the north side of Main Street. An 1872 courthouse was erected on the present site, and it was remodeled in 1913. (Courtesy of Grubb Photo.)

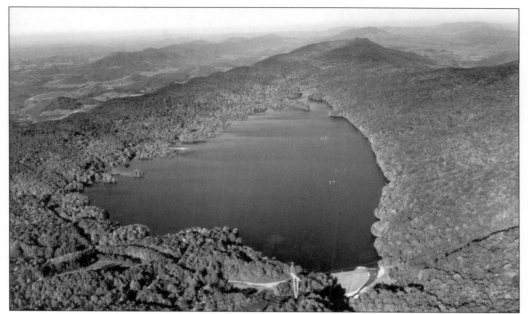

Laurel Bed Lake, one of the highest lakes in Virginia, originates in Tazewell County. From this high vantage point, the scenic view looks into Thompson Valley to the right and Witten Valley to the left. (Courtesy of Grubb Photo.)

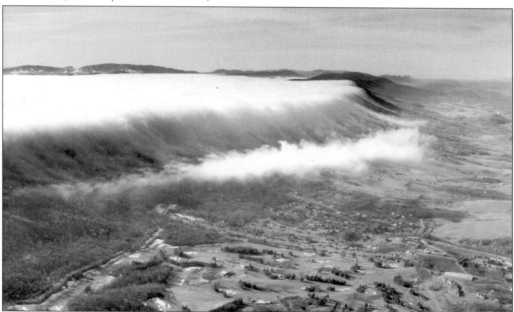

This well-known photograph of fog over East River Mountain, taken on a December day in 1993 by Mel Grubb, records a weather phenomenon combined with the natural beauty of the mountains. From the vantage point of the aerial photographer, Grubb said, "the fog extended as far as the eye could see 60 to 70 miles. Most fogs will dissipate after the sun rises and warms the air. In this case the fog continued to shroud the mountain well into the night." (Courtesy of Grubb Photo.)